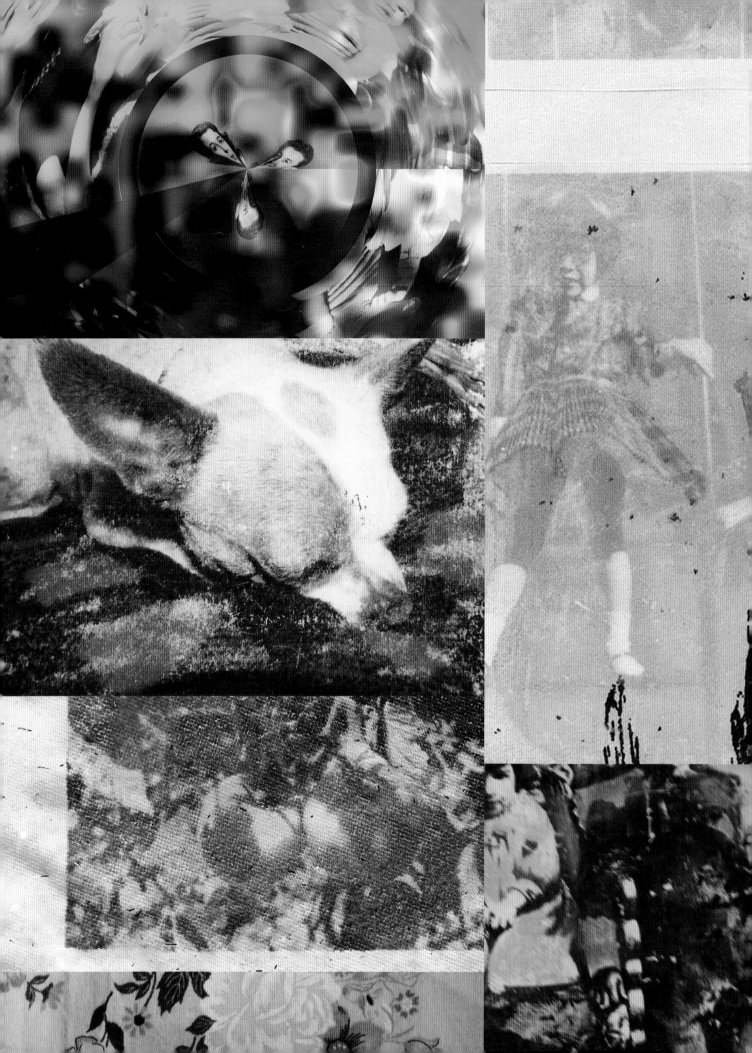

DIGITAL IMAGE TRANSFER
Creating Art with Your Photography

Ellen G. Horovitz

PIXIQ

An Imprint of Sterling Publishing Co., Inc.
New York

Art Director: Tom Metcalf
Cover Designer: Thom Gaines
Production Coordinator: Lance Wille

Library of Congress Cataloging-in-Publication Data

Horovitz, Ellen G.
 Digital image transfer: Creating art with your photography / Ellen G. Horovitz. -- 1st ed.
 p. cm. -- (Magic lantern guides) (Magic lantern guides)
 Includes index.
 ISBN 978-1-60059-535-6
 1. Art--Technique. 2. Photography--Digital techniques. I. Title. II. Series.

 N7433.H67 2011
 776--dc22

 2011000342
10 9 8 7 6 5 4 3 2 1
First Edition

Published by Pixiq, A Division of
Sterling Publishing Co., Inc.
387 Park Avenue South, New York, N.Y. 10016

Distributed in Canada by Sterling Publishing,
c/o Canadian Manda Group, 165 Dufferin Street
Toronto, Ontario, Canada M6K 3H6

Distributed in the United Kingdom by GMC Distribution Services,
Castle Place, 166 High Street, Lewes, East Sussex, England BN7 1XU

Distributed in Australia by Capricorn Link (Australia) Pty Ltd.,
P.O. Box 704, Windsor, NSW 2756 Australia

If you have questions or comments about this book, please contact:
Pixiq
67 Broadway
Asheville, NC 28801
(828) 253-0467

Manufactured in China

ISBN 13: 978-1-60059-535-6

For information about custom editions, special sales, premium and corporate purchases, please contact Sterling Special Sales Department at 800-805-5489 or specialsales@sterlingpub.com. For information about desk and examination copies available to college and university professors, requests must be submitted to academic@larkbooks.com. Our complete policy can be found at www.larkcrafts.com.

Acknowledgements

Many people and companies have contributed to the fruition of this book, but some just have to be named. For starters, had it not been for the dogged insistence of artist and friend Amy Burkholder, this book would never have seen the light of day. It was she who continually hammered me to contact Pixiq and see if they would bite at the idea of this creation. So thank you Amy, for your persistence, and may your work subside so you can contribute to the next book.

There are also many generous individuals (and companies) who not only encouraged my creative efforts but also contributed to them. These include: Edward Spiegel of UI Software for the entire ArtMatic Suite; Candice Pacheo and John Dalton of Synthetik Software, Inc. for their Studio Artist software, and for allowing me to review their Beta versions of upcoming releases and for continued interest in my project; Douglas Little of Wacom Technology Corporation for his generous contribution of Wacom tablets; Kelly Manuel form Corel for her contribution of Painter software; Geraldine Joffre, Managing Director of HDR software and her contribution of Photomatix Pro software; Marilyn Sholin for her sage advice and direction; Linda Stemer of Blueprintsonfabric.com for her contribution of blueprint fabrics and papers; Katie Beswick at Grafixarts.com for her contribution of Grafix photographic papers; Britta DeVries, Mary Chernoff, and Andrew Staples at Epson America, Inc. for their generous contribution of printers and scanners; Simone Young and Mike Kelly for their contribution of Lazertran papers; Melissa Zeitler at CitraSolv.com; Jessica Isolek from cre8it.com for her contribution of Sheer Heaven paper; and Greg Wind, Zachary Heath, and Wendi Winfrey at Kubota Image Tools.

I also wish to acknowledge my peerless editors who made this entire experience a joy from beginning to end: the amazing and ebullient Marti Saltzman and first class editor Kevin Kopp, whose vision not only shaped this book but also encouraged its completion.

Finally, I would like to acknowledge my family, especially my champion and husband, Jay (Eugene) Marino; my dear friends (specifically Karen Armstrong); and all the artists who contributed to the work in this book. As well, many students, artists, writers, and teachers, past and present, have influenced and inspired my endeavors.

And thank you Pixiq for believing in me and offering me this generous opportunity.

-e.g.h.

This book is dedicated to my beloved husband Jay, and in loving memory to Steven L. Horovitz (4/26/60 – 8/7/09),
who was the light behind my family's lens.

contents

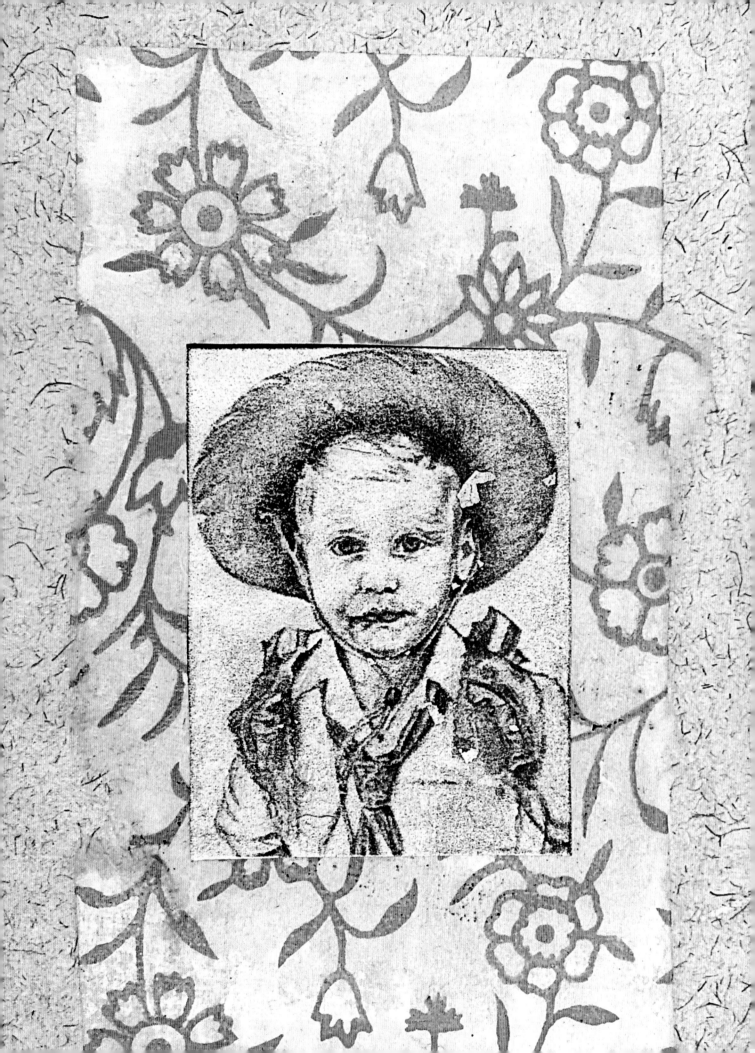

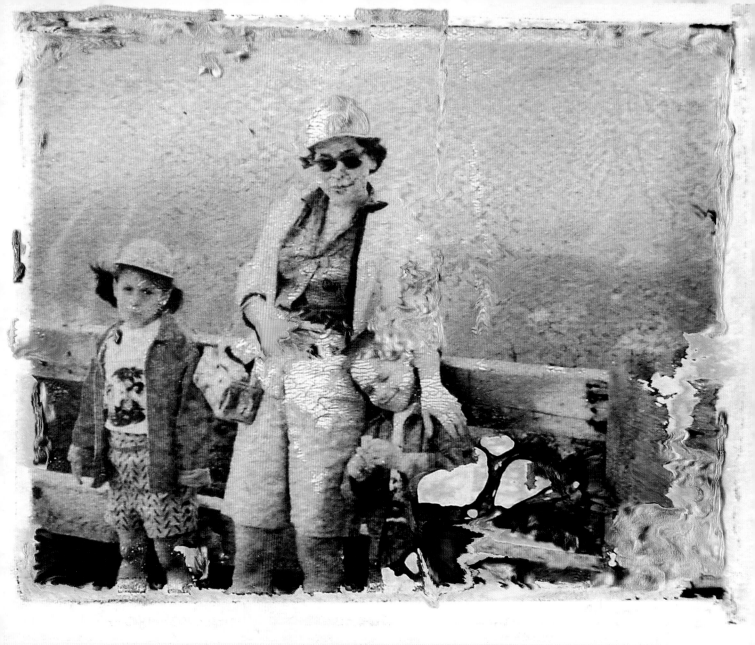

Introduction

> "A lecture is the best way to get information from the professor's notebook into the student's notebook without passing through either brain."
>
> — *(My) Three Principles of Effective Online Pedagogy; Pelz, B.; JALN Vol 8, Iss 3; June 2004 pp 31.*

Lectures, as pointed out by the above quotation, act like a sieve: most of the information drains away. So instead of lecturing, I intend to show throughout this book in step-by-step fashion how to transform your photographs and artistic creations into a number of different creative formats, from fine art to wearable craft. We'll begin the process by taking images—analog or digital—and manipulating or processing them in software applications such as Photoshop, Studio Artist, Painter Essentials, and ArtMatic. So instead of tossing out your analog images, negatives, and /or film transparencies, you will assimilate what can be done with the old (analog) and the new (digital). This book will explain how to repurpose your images and recombine them to produce art.

The gist is to embrace your photographs and transfer your artistic imagery onto an array of substrates. New materials such as Sheer Heaven and Grafix, along with their applications, will be introduced. You may well find "happy accidents"— new ways to use materials or new techniques that present themselves unexpectedly throughout the process and allow you to produce everything from framed art photos to apparel to fabricated jewelry. For instance, I'll review how you can create art from the resulting byproducts of photographic imaging. This byproduct, much like outsider art, will take on new meaning as your "ghosts" (project cast-offs) lend themselves to new uses other than your original intention. This ends up delivering environmental (green) art, which will encourage you to salvage all aspects of your projects for additional artistic measure. In short, ideas will abound for fashioning your images into formats other than conventional digital output and/or photographs. You will find yourself using digital technologies side-by-side with traditional, tried and true crafting methods to produce unique artwork.

Please take note that all image-processing software programs are periodically updated by their manufacturers, so your version may not look exactly the same as the screen images I used to illustrate the steps in this book. However, differences between the way your screen looks and the screen grabs in this book will be minor, so don't let them become a big concern.

I encourage you to fearlessly break the rules and look at all of the possibilities at your disposal in terms of materials and techniques. Combine and juxtapose, toasting the marriage of uncomfortable bedfellows such as scrapped images fused onto glass, or instant film negatives and a "painted" ink-jet print. I bid you to play and above all, ever art.

-ellen

software basics

As a fine arts artist and photographer, I have not always been adept at navigating image-processing software. I used to be a stranger to imaging programs like Photoshop, Studio Artist, Painter, and Artmatic. But, I came to realize the artistic potential these programs offer, and I appreciated that I could find new ways to create mixed media projects with at least a basic understanding of this "computer" end of the process. So I learned the basics and more. Now, I embrace the exquisite capability and technical magic these programs present as powerful tools to alter my digital images and depict my vision.

Maneuvering your digital photos in these software programs will alter your assumptions about images, allowing you to endlessly adjust, change, and embellish your pictures. But first, it's important to understand some of the fundamentals with regard to Photoshop, Studio Artist, Painter, and Artmatic, so you can create in ways not easily possible before the digital age. While I love to work in real paint, clay, and various media, I've found that I can be just as creative if not more so with a Wacom tablet and computer monitor. I hope these software basics will whet your appetite and engage you to dive in and use them to further enhance your creativity in the projects that follow.

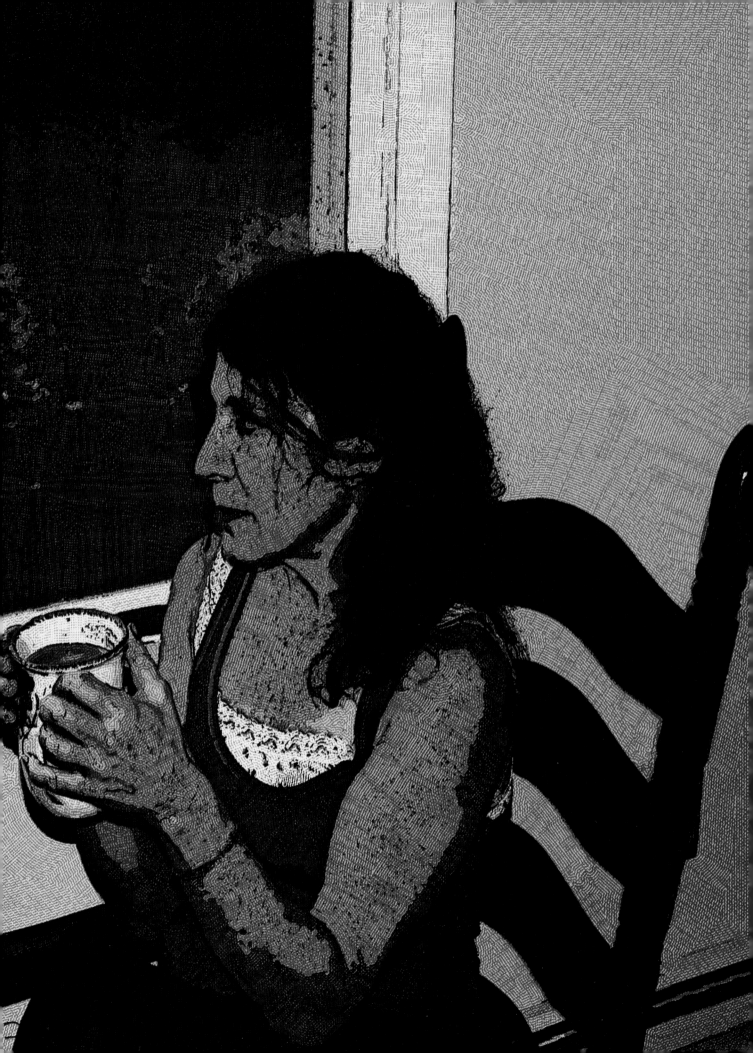

From Color to Black
and White with Photoshop

While there are numerous software programs that you can use to process your digital images, (including free downloads like Gimp, available for PC and Mac), Photoshop from Adobe has established itself as perhaps the premier product for altering and enhancing your digital photo files. I like to think of Photoshop as my body repair shop for images. It is also a great program for converting from color photo files to black and white, including the output digital negatives (or inverts). These are basic but necessary procedures for creating some of the projects found throughout the rest of this book, such as fusing on glass, making cyanotypes, and others.

Some people may opt to create a black-and-white photo simply by highlighting the program's Grayscale option that simply discards the image file's color information. However, I find more control by using the Black & White icon (circled in lower right) found in the Adjustment toolbox, (Windows····⟩Adjustments). This offers the best options for mixing the different colors within the photograph to produce the optimal output for your black-and-white image and/or invert.

Converting to Black and White

Since there are often multiple ways in Photoshop to go about producing an effect, you may already know additional methods to achieve certain results. But always make sure to create a duplicate of the original image file before you begin any conversions, saving the new file under a different name. Otherwise you run the risk of saving over your color image and losing it to the ages, never to be regained.

Note: There are plenty of websites that have online training for step-by-step applications of image-processing software. Use the Internet to search for tutorials of your favorite program.

Step 1: Open your image in Photoshop and make sure the Layers tab is displayed in the palette (Window ····⟩ Layers). Then click on the highlighted background layer to change the name from "Background" to something different, such as "Layer 0," because the layer is locked until you do so.

Step 2: Go to the Window menu and click the Adjustments option in the drop-down (above) to open the Adjustment toolbox tab in the palette (below). A series of small rectangular icons will appear near the top of the window as well as a list of drop-down presets right below the icons. A brief description of each icon displays when you hover over it with your mouse. For example, from left to right (in the top row), hovering will indicate Brightness/Contrast, Levels, Curves, and Exposure. Clicking on any of these selections will create a corresponding adjustment layer.

Step 3: Click on the Black & White icon, a rectangle divided diagonally with a black upper half and a white lower half. Your image in the program's work area will immediately change from color to monochrome, though the digital image file still retains its color information. In addition, you will see a set of sliders (top right) that allows you to control the contrast of the different colors—how bright or dark they look—as you render them to monochrome mode. On the other hand, using the Grayscale option described a little earlier (Image····❯Mode····❯Grayscale) merely discards all color, which disallows any tonal control over the image.

Once satisfied with the way your black-and-white image looks, click on the arrow in the lower left corner of the Black & White palette (second from top). This takes you back to the Adjustments toolbox and gives you the opportunity to work with additional adjustments tools as desired.

Step 4: Now click on the Brightness/Contrast icon (a sun that is half black/half white) to open that tool in the Adjustment toolbox. Again a window will display with sliders that allow you to adjust the brightness and/or contrast of the image (third from top).

Step 5: Open the Levels icon (a graph that looks like black mountains against a white background) and use the triangular sliders at the bottom of the histogram to adjust the contrast and density for shadows (black), midtones (gray), and highlights (white). See bottom right.

Step 6: When satisfied with the appearance of your image, it is time to flatten it (combine all the layers you have just created into a single one). Go to the Layer drop-down in the menu bar to select the Flatten Image option, or click on the downward-facing triangle in the Layers tab of the palette, and select Flatten Image (top right).

Step 7: You can now save the image as a black and white, and don't forget it should be saved as a differerent name than your original color image file.

Step 8: An additional option is to change the image again into an invert, which may be useful for other purposes. This is like making your digital file appear as a black-and-white film negative, where the tones are reversed from the positive image (bottom right). You can do this by having your black-and-white version open in Photoshop and selecting the Invert option (Image ┄┄⟩ Adjustments ┄┄⟩ Invert, middle right). Again, don't forget to save this file with another name (File ┄┄⟩ Save As) or you will lose the black-and-white image you previously created.

Note: When the time comes to transfer the invert digital file, you will output it onto a transparency medium.

An invert, or digital negative, is a reversed-tone black-and-white image.

Tinting

I really like this kaleidoscope piece in black and white (right), which was created through a series of involved steps that can be found in my colleague John Neel's book, *Rethinking Digital Photography*. I became curious to see what the image would look like if I added a sepia tint to it. By using the same black-and-white filter in the Adjustment toolbox that was described previously, you can easily convert color (or black and white) to another hue. When you check the box marked Tint in the Black & White palette of the Adjustment toolbox, a larger colored square will appear next to the check box, and the image will convert to a tint of that color (lower right). Choose an alternate tinting color by clicking inside the colored square. A box called Select Target color will appear. There you can move the vertical color slider to select the tone that you desire. Press on OK to return to the Adjustments toolbox.

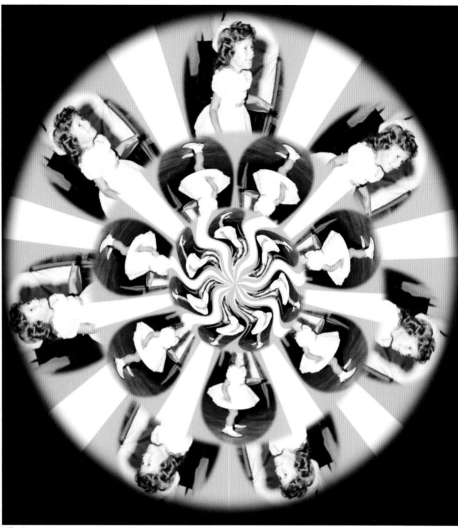

Elly Dances.

Here the sepia tone takes the viewer back to the era that this was shot, adding to the 1950's quality of the final output.

The photo of my father (right) resembles a cyanotype, but was actually "tinted" in Photoshop. Using software is fast and clean because I can quickly produce the same blues that result from cyanotype chemical processing, yet no chemicals are involved. It is a lot of fun to mix and match techniques, combining them to produce all kinds of interesting and unique works. You can also select sections of your photograph and work in layers, choosing specific portions of the photograph to receive tinted color (below).

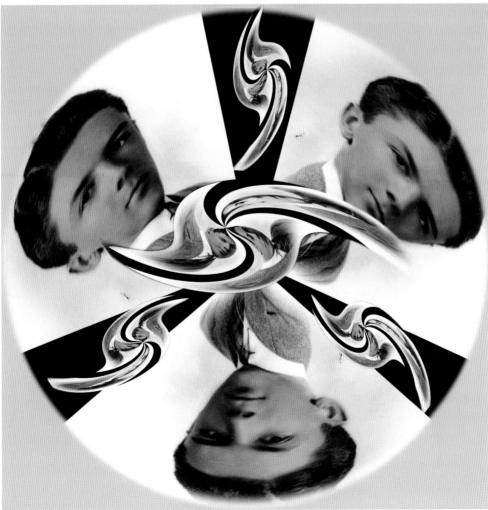

Using Studio Artist

Of all the software programs that I have used, Studio Artist is my favorite. While primarily created for digital painting, the editing tools in this package offer numerous visual effects for use with your photographs and/or drawings. While it isn't necessary to use a Wacom tablet with Studio Artist—or with Painter Essentials for that matter (a program described on pages 26-35)—a tablet offers much more control and a much more natural way to write, draw, or paint. A mouse can't match a stylus in terms of bearing, pressure application, and line sensitivity.

There are several different styles, sizes, and price ranges for Wacom tablets, and I definitely recommend one for any photo digital artist. The Bamboo line is the most affordable. I use a wireless Intuos model and like to prop the tablet in my lap while looking at my monitor to see the results. An imaging program combined with the Wacom tablet is like using paints without the setup or cleanup.

The choices within this program are endless due to the innumerable brush styles available. Even if you use just a few of the brushes, the results can resemble stunning, hand-painted artwork. You are also able to make adjustments to the parameters of the different brushes. Since there are so many brush selections, Studio Artist has a feature that enables you to save your favorites and place them in a palette along the top edge of the program (in the Property Bar next to the heart icon, see the illustration on the top of the next page). Each time you restart Studio Artist, these brush choices will show up in your Favorite's palette. As well, you can download more brushes from the web if you don't feel the program has enough choices.

The Wacom product line includes a wireless model. The blue light on the right side indicates that the Bluetooth connection between the computer and the tablet is operating. Photo from Wacom.

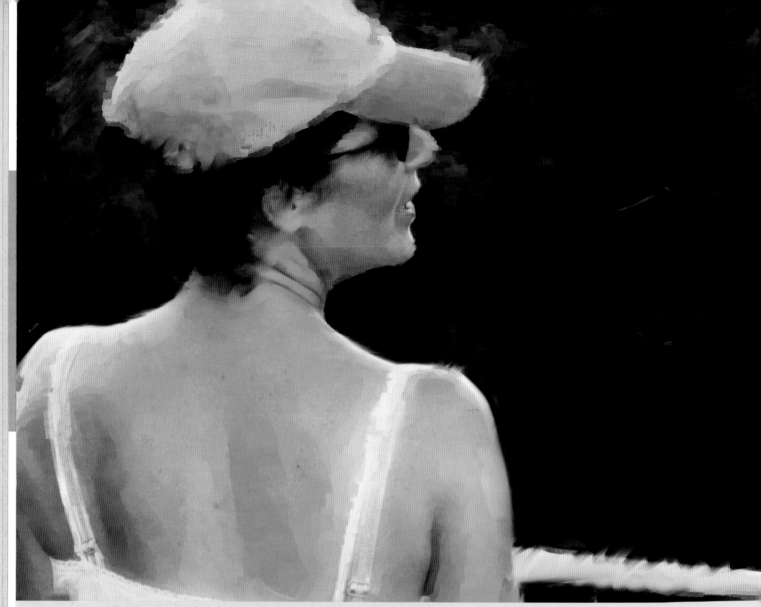

Karen, Kayaking. Painter Essentials from Corel allows you to make your photo images look as though they were made using a brush and canvas.

Painter Essentials

Painter Essentials 4 from Corel utilizes many of the features employed by its more complete sibling, Corel Painter, but it is simpler to use and less expensive. The nice part about Essentials is its intuitive nature and the ease with which it operates. The two palette tabs located at the top right of the workspace (Drawing & Painting for color control and Photo Painting to determine brush strokes and styles for pictures) allow you to interact between both palettes. The Property bar—immediately beneath the topmost Menu bar (opposite top)—gives information about the tool that is in use at any particular moment. For example, after selecting a brush from the Brush Drawer, you can easily adjust its size, grain, and opacity. The Property bar also contains the Undo and Redo buttons (curved arrows) in the top left corner. Painter Essentials offers 32 levels of do and undo, a nice feature while working on your projects.

Note that the image you are working on displays under Source Image in the Photo Painting tab.

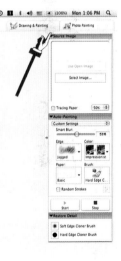

In the vertical Toolbox to the left of the Brush Drawer you will find a number of icons, such as the magnifying glass (Zoom tool) that allows you to zoom in and out, or the hand (Grabber tool) that allows you to pick up the image and move it around and/or navigate to the area where you want to work. The Rotate tool (circular arrow below the Grabber) allows you to turn the image when, for example, you might want a more comfortable position in which to draw a vertical or horizontal line. Double-clicking on the rotate tool returns you to the default position.

There are also several Fly-Out tools (specifically the Dodge and Burn, the Layer Adjuster, and the Selection tools) within the Toolbox. Clicking on the small triangle alongside these tools easily accesses additional options (they "fly out" from the Toolbox). These Fly-Out tools also let you select alternative options above the Toolbox in the Property bar.

The very important Brush tool is always at the top of the Toolbox and is opened as a Brush drawer by clicking the small arrow icon next to it (circled above). Several categories across the top of the Brush drawer allow you to organize the various media within Painter Essentials. Each is located by name and stroke preview; this allows for quick review of the particular look that you are trying to obtain. As you click on the specific

icon, you will see it show up in your Brush drawer. As you select various media, you will build a column in the Brush drawer. Holding the cursor over each one calls out the name of each medium. Like in the Studio Artist imaging program (previous section), there is a Favorites list: select a tool and then click on the plus sign at the bottom of the Brush drawer to add it as one of your favorites. To remove it, simply click on the tool and drag it out of the Favorites list—you will see that the plus sign changes to a negative sign, thus deleting the tool from the Favorites list.

Now that you have a basic grasp of the tools within the program, let's get started with the process for enhancing your photo images.

Photo Painting Tab

Palettes are always located on the right side of the screen and, depending on which workspace you happen to be in (Drawing & Painting or Photo Painting), you will see a different set of choices. The Photo Painting tab allows you to make a painting from an existing photograph. You can choose to paint over a photo by hand, or use the Auto-Painting palette, which lets you control such aspects of

your enhanced image as its edges, color, paper quality, and brush-work. Depending on how you use the settings, you can get a wide variety of outcomes. Explore the painting enhancements further when working with the different tool variations.

The Auto-Painting tool is at the heart of this tab. Let's take a look at how much fun you can have using it.

Step 1: In the Photo Painting tab, go to File ····} Open and select an image from the displayed browser. You will next need to click on the Use Open Image button in the Source Image palette in the upper right area. A thumbnail image appears in the Source Image palette while the main workspace is at first blank. However, placing a check mark in the Tracing Paper box allows you to control the vis-

ibility of the image in the Canvas area by using the percentage drop-down (below). The higher the percentage value, the more veiled the source image appears, but the easier it will be to see the painting enhancements you apply. You may want to turn your tracing paper on and off to see how you are progressing.

Step 2: The drop-down bar within the Auto-Painting palette contains a number of preset painting styles representing a constellation of selections (opposite top). These allow you to control the way your source image can change, offering the ability to alter the shape of the edges of your image, color scheme (Classical, Impressionist, etc.), simulated paper type (rough, watercolor, etc.), and/or brush options (Chalk, Scratchboard, etc.).

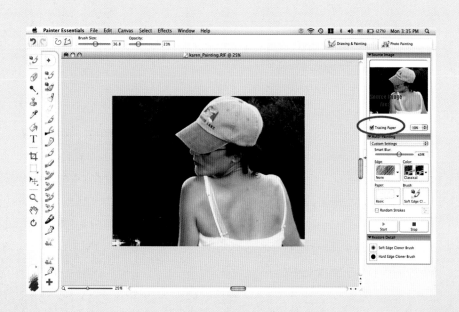

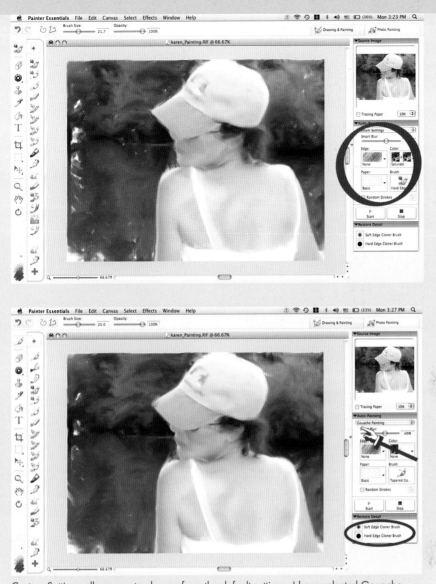

cific areas of your photo to restore certain portions that have been altered. For example, you can restore the details to a subject's face. You can adjust the settings for these brushes on the Property bar. To accomplish this, go to the Restore Detail palette and click on either the Softer Edge Cloner brush (that restores detail in a gradual manner) or the Hard Edge Cloner brush (restored detail quickly with just a few brush strokes). Use these to paint over the area in which you want to restore original detail.

Custom Settings allows you to change from the default settings. I have selected Gouache Painting from the Custom Settings drop-down menu in the Auto-Painting palette. To begin, simply press the Start button. Press the Stop button when you are satisfied.

Step 3: Once you have made your settings in Step 2, you are ready to apply them with the Auto-Painting process by clicking the green Start button in the lower portion of the Auto-Painting palette. As you allow the Auto-Painting to continue, it spends more and more time on the edge and detail portions of the image. Some presets take a relatively long time to complete while others are much quicker. You can stop the procedure by clicking on the Stop button or by clicking on the image in the work area.

One important aspect of Auto-Painting is the ability to restore image detail by using the Restore Detail palette (lower illustration above). This palette gives you access to two cloner brushes— Soft Edge cloner and Hard Edge cloner—that you can use in spe-

Hint: Smart Blur applied at a 100% eliminates a lot of the photographic details from the images, leaving a general softness, but preserves the edges of the image as well as the softness of all the remaining areas.

Drawing and Painting

The tab for this workspace allows you to control color and tone while using a photograph as a reference to make a sketch or drawing, taking advantage of the Tracing Paper feature. The Colors palette at the top of the tab (right) mirrors what you would find as traditional paint-tube colors, so you will find that to be very familiar if you are used to working with paints. There is also a Mixer palette that allows you to combine colors. You can then use the Dropper to choose a mixed color for your painting, or you can click on the color wheel to select hues and tints and shades of each color. Apply the chosen color by selecting a brush and painting on your source image.

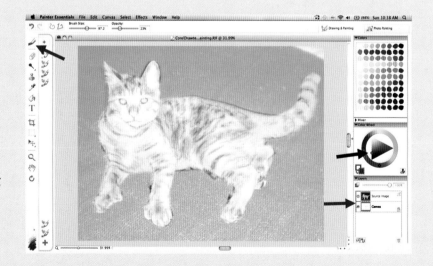

Step 1: Open an image directly in the Drawing and Painting tab by going to File ·····⟩ Open. Or you can open an image from the Photo Painting tab and then select Use Open Image. This creates a clone of your image. Again, you activate the tracing paper to see the image underneath it in the canvas area. Experiment with tracing percentages to see what works best in terms of seeing both an image beneath the trace and the ability to see the brush strokes you apply.

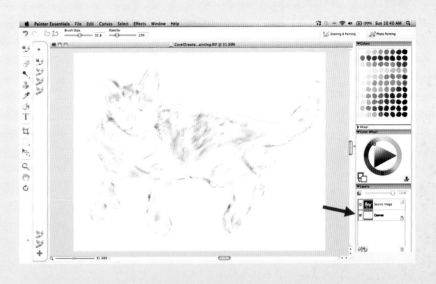

Step 2: If working from a photo, switch from the Photo Painting tab to the Drawing and Painting tab. Select colors and brushes as needed to artfully manipulate the image. For example, in the bottom illustration on the opposite page, I have chosen a black and white image of my cat, Vinny Jasper, and a chalk tool from the Brush Drawer to follow his outline.

Step 3: Check your progress from time to time. Hold the Control + T keys to turn the photograph on and off (top right, note that Canvas is highlighted in the Layer drop-down).

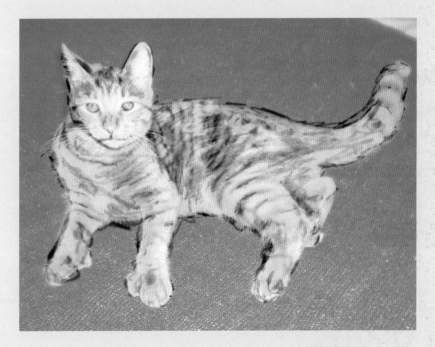

Step 4: Making changes to the image will automatically create layers. When satisfied with your results, you can collapse the layers to flatten the image, merging their contents with the Canvas. But, I often take the Painter file into Photoshop to enhance it even more, as I did for my final image of Vinny Jasper (see lower right).

If you like to make original drawings, you can also sketch in the Drawing and Painting Canvas without using a source image. The colored cat at the top of the opposite page is an example of a drawing I did that is not based on a photograph. I made selections from the Brush Drawer and Property Bar, then used my Wacom tablet and pen to create this yellow cat. I additionally applied Effect·····⟩Surface Control·····⟩ Woodcut to give it a woodcut finish in specific areas. I finished this particular piece by taking it into Photoshop for some final enhancements.

Saving Your Files

You can save your Painter Essentials' images in the RIFF format with "live" layers—the layers continue to function when you reopen the file. You can also save your Painter Essentials' images as PSD (Photoshop) documents. If you save a file to a file format other than RIFF or PSD, the layers drop (or merge) into a single background image.

I love the interplay between various software programs, sometimes processing a file within three or four different programs before settling on a final image. I selected a profile of my friend Karen and saved it after enhancing it in Painter Essentials as a PSD file so that I could further manipulate the image in Photoshop. As you can see in the illustration below, I can do some things in Photoshop to complement Painter Essentials' capabilities. I then went back to the original Gouache in Painter to resize it before also saving that version and also producing a final enhancement in Photoshop (lower right).

This is the original photo of Karen, before working on it in both Painter Essentials and Photoshop.

Gallery

Following is a set of images that have been processed through Corel Painter Essentials. There is so much more you can do with Painter, so I advise you to download a trial version available from the Corel website and work with the tutorials that are included.

My Boyfriend. This image was recorded off of a television screen with a Blackberry camera phone before being manipulated in Corel Essentials.

Hitting a Brick Wall. © Kaitlyn Darby.

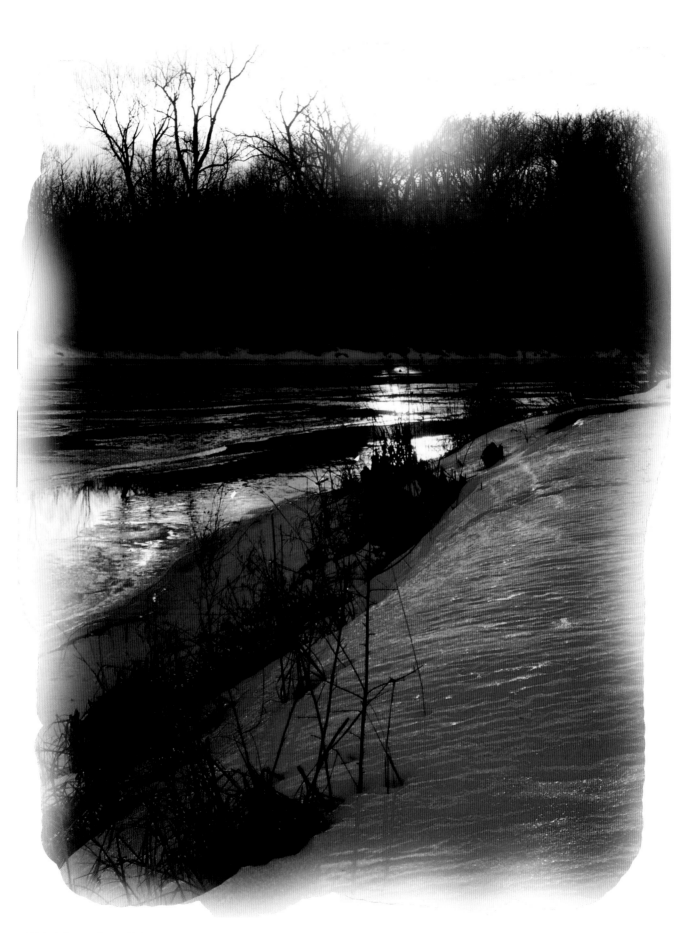

Walnut Street, Sunset Light.

Gallery

The following pictures demonstrate the extent to which you can transform digital photos using ArtMatic.

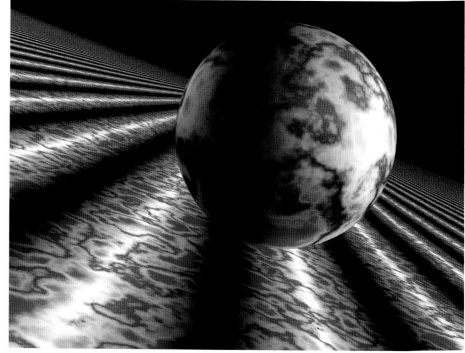

Planet Layer.

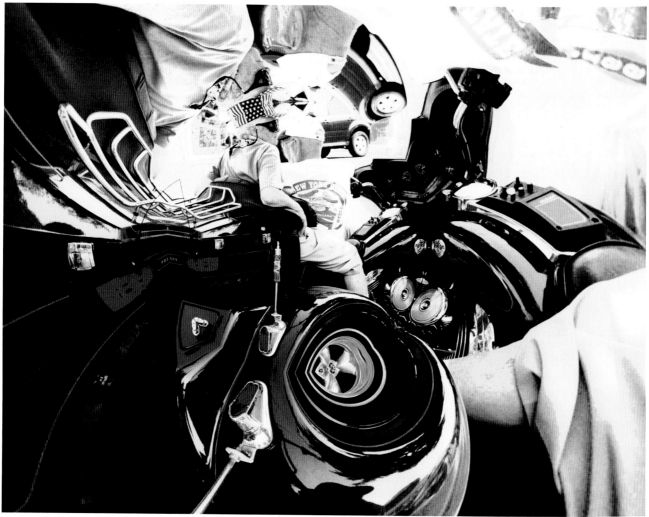

Motorcycle Mama.

Car Guys.

Family, without Me.

image transfer

A substrate is any base material upon which you output an image. Examples of substrates used in mixed media art projects include paper, fabric, wood, polyclay, and metal. But you can't always reproduce a photo file directly onto one of these materials since, for example, it's difficult to run a piece of wood or sheet of metal through an inkjet printer. Therefore, you often have to find a way to transfer the image to your desired substrate. And that's what this chapter is about.

Frequently the type of machine needed to reproduce the image for transfer—inkjet printer, laser printer, photocopier, scanner—is determined by the substrate you want to use and may require specialty papers for transfer. Such specialty papers, like those from Sheer Heaven, Lazertran, and Grafix, are useful in enabling the transfer process by recording the image from the printer and reproducing it onto your chosen substrate.

There are a number of additional techniques using solvents, transparencies, film, glass fusion paper, and other media to move image files and prints onto varied surfaces. In this chapter, we will explore many of these methods that allow you to create art projects from your existing analog or digital photos, or from images that you have manipulated using software programs like the ones described in the first portion of this book. The idea is to push the envelope and rework an image and perhaps gain a new artistic perspective in the process. To start, let's consider the different kinds of reproduction hardware commonly used in the transfer process.

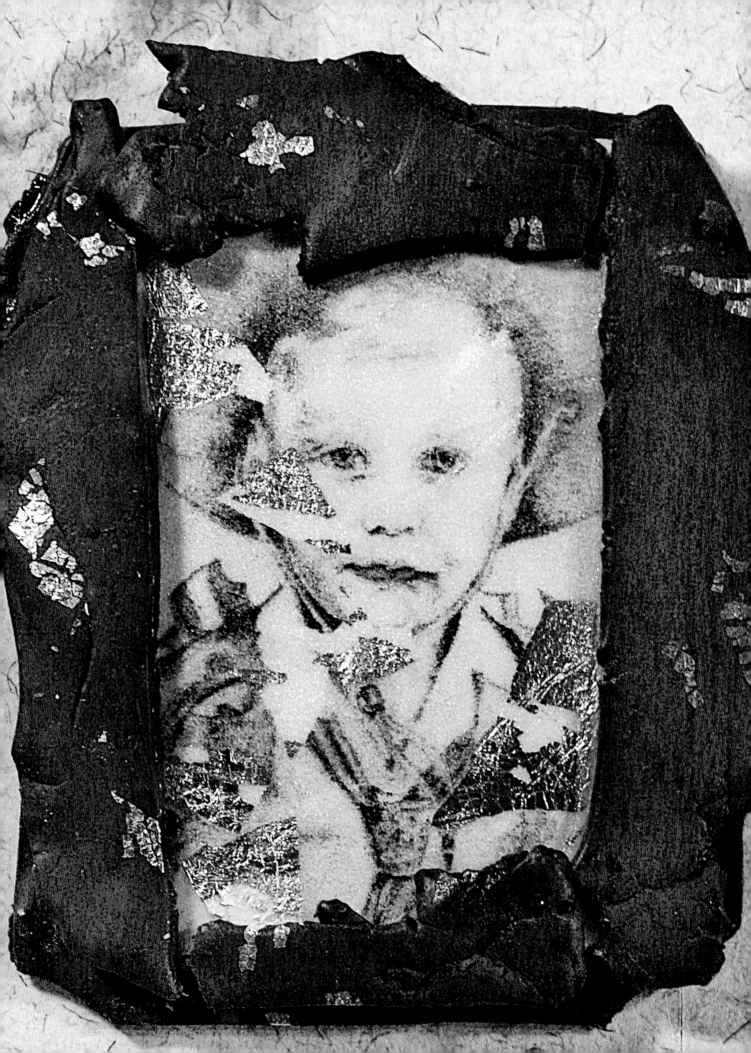

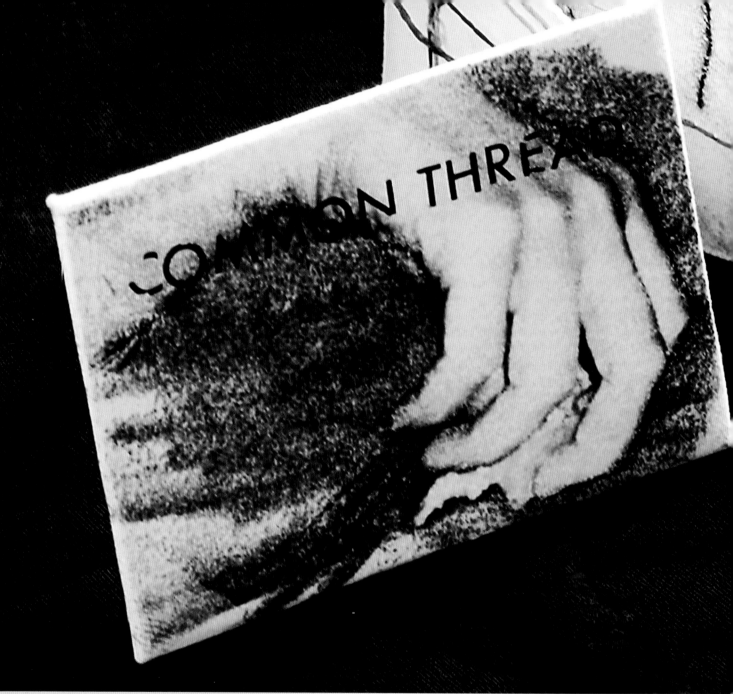

Common Thread by Elizabeth Brandt ElBayadi.

Primary Hardware Used for Image Transfers

Aside from your computer, you will find the need for at least one of several different machines to help you complete your transfer work. The type of hardware you use can be important in determining what kind of materials and substrates you end up utilizing to produce your mixed media art pieces. Here's a quick rundown.

Inkjet Printer

This type of printer uses minute droplets of ink that are sprayed onto its output paper. For our purposes, the idea is to print onto a medium that can then be used as a transfer agent to apply your image onto the chosen substrate. This transfer medium could be regular bond paper (see the Healey method, pages 92-95) or photo matte paper, but specialty media will usually produce the best results. Some specialty papers are made particularly for use with inkjet technology (Sheer Heaven, Grafix Inkjet Shrink Film), while others are made for exclusive use with laser printers/and or photocopiers (heat-based technologies). Trying to print on laser transfer media using an inkjet printer (and vice versa) will usually result in poor quality output, although I have experimented with inkjet paper and found a way to transfer the image from a laser printer (see page 77).

Laser Printer

Laser printers use heat transfer, as opposed to the droplets found in inkjet printers. This means that particles of dry ink (toner) are picked up by an electrostatically charged drum to reproduce the image by direct contact, using heat to fuse the ink to the me-

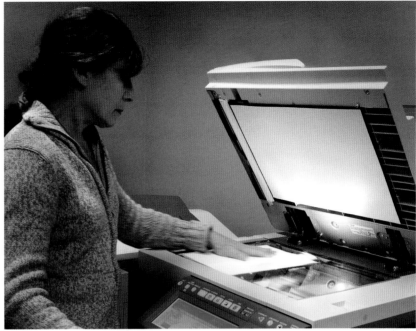

The photocopying machine can become a creative tool in altering and transferring pictures from one form to another. Here I am using it to make a manipulated reproduction of a print. Photo © John Neel.

dium. Laser printers can print on bond laser paper or, as noted, on a variety of specialty transfer papers made for heat-based printing, including some types from Lazertran and Grafix for placing your work onto wood, leather, silk, metal, glass, polymer clay, or even ceramic substrates.

Note: Heat-based methods are essential when using such commercially available solvents such as acetone, Xylol, or Citra Solv (see pages 98-103).

Photocopy Machine

Photocopiers also use heat-based technology to fuse a reproduced image onto plain bond or specialty paper. One neat trick is to wiggle and/or move a photo or drawing over the glass plate of a photocopy machine to distort the image. While it has become commonplace these days to enhance and manipulate pictures using various software programs, there is still something special about moving an image back and forth or in circles over the copying surface of a photocopy machine (or scanner), and being surprised by the resulting picture. For example, in the black-and-white picture on page 49, I altered a print of my mother and me by moving it around in a zigzag fashion during the copying process to create a distorted view.

Scanners

This device optically scans images, printed text, handwriting, or an object, and records the subject as a digital image. Even images that have been altered by other processes and produced onto another surface such as wood or fabric can then be scanned back into your computer for further manipulation and/or output.

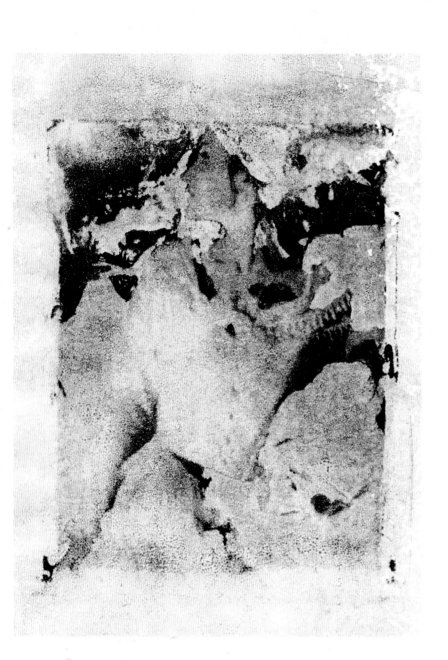

Val. A negative emulsion transfer using an instant film print that was transferred onto vellum. That print was then scanned, and the subsequent digital file was output with an inkjet printer using Sheer Heaven, which was then transfered onto vellum paper for this final fine art print.

Gallery

Whether making prints from an inkjet or laser printer or photocopy machine, there is a huge variety of transfer media and substrates available to you, leading to infinite possibilities for transforming your photography into art.

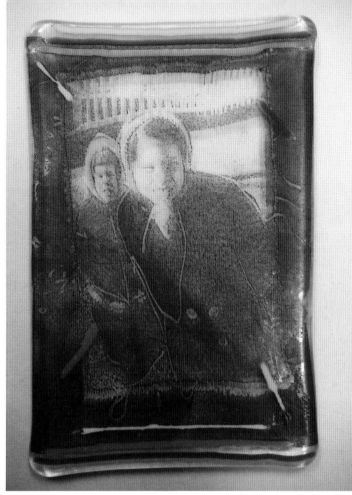

A cyanotype was scanned and converted to black and white, then printed on fusing paper in a laser printer and transferred onto clear glass with colored stringers. The glass was then fired in a kiln to fuse the paper (see pages 116-123).

'f-Box. A mixed media project with India ink, acrylic paint, and a anned collage of hand-drawn images that were printed using an inkjet nter on cardboard. Artwork by Roderick Castle.

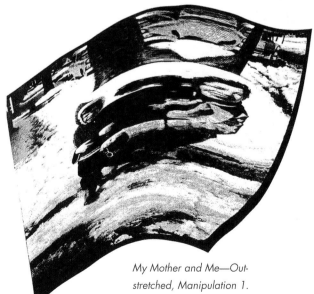

My Mother and Me—Outstretched, Manipulation 1. This image was produced by moving a print back and forth as it was being photocopied.

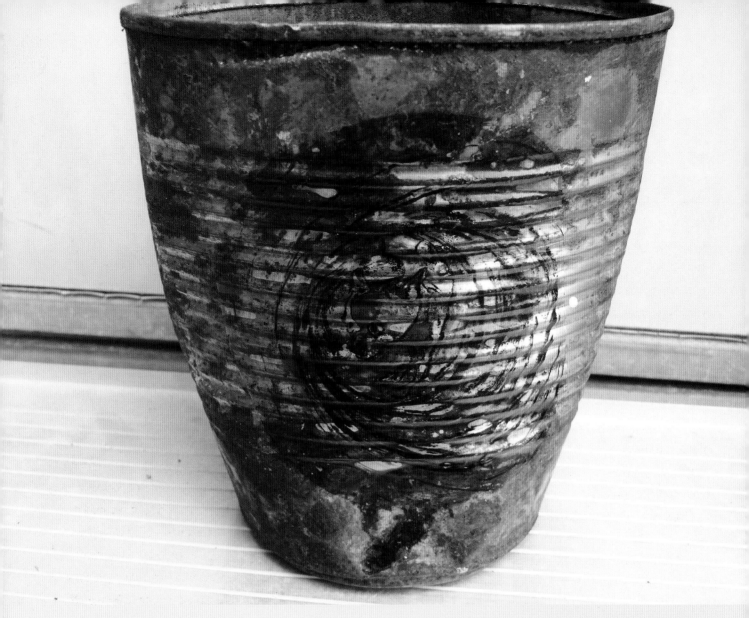

Basic Transferring to a Variety of Substrates

I find it intriguing to photograph a scene and then imagine the possibilities for using that picture with various media. By using methods ranging from software enhancement to assorted transfer techniques, you can recast your artwork as many times as you want. Your original photograph can be endlessly manipulated and recreated in multiple media, including clay, glass, wood, metal, fabric, paper, and others.

For example, after altering a digital photo of my dog Lola in Studio Artist, I opted to print it on Lazertran laser paper, which produces an output that is like a decal. Then I soaked the Lazertran image in water for a few minutes. Simply remove the backing paper from the transfer decal and the Lazertran image adheres to nearly any substrate, such as a discarded metal can above.

We'll look in-depth in later chapters at a variety of the most intriguing and valuable transfer methods for placing photos and images onto a wide assortment of substrates, but don't be afraid to experiment. This will expand your ability to make beautiful and unique mixed media art projects. In the meantime, let's take a quick look at the versatility of image transfer.

Wood Substrate

The best results when transferring to a wooden substrate are produced using a heat-based process. As I did with Lola and the tin can, I like to use a transfer medium called Lazertran Waterslide Decal paper, which is designed for use with older-style dry toner color photocopiers that use silicon release oil. Some desktop laser printers also work well with this paper. A complete list of printers that are compatible with this type of Lazertran paper is available on the Lazertran website. However, if your copier or printer is not compatible, you can try the Lazertran Waterslide Decal paper for inkjet printers. Bear in mind that the Waterslide Decal paper for inkjet printers delivers best results when oil-based polyurethane is applied to permanently fix the images after they have dried.

Step 1: Print your artwork from a laser printer or photocopy machine onto Lazertran Waterslide Decal paper. Make sure you know which side receives the image—if using a photocopy machine, run a test on bond paper before using the Lazertran paper (most laser printers indicate which side receives the image). And don't throw the test print away—you can use that later for byproduct art using a

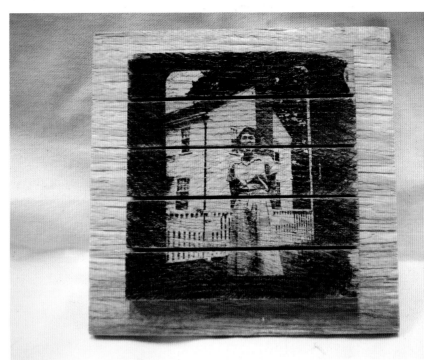

My Mother. This old picture was transferred using Citra Solv.

solvent (see pages 146-155). Next, allow the print to dry at least five minutes (30 minutes if you choose to use an inkjet decal). Then, cut out your image from the print. Eliminate any white borders with an X-acto knife and/or scissor.

Step 2: Place the Lazertran image in lukewarm water for approximately 30 seconds (60 seconds if using an inkjet decal); the paper will begin to curl. The image will be ready to transfer when you are able to slide the printed image off the white backing paper (below).

Photo © Kim Kernehan.

Step 3: Place the image onto the substrate and remove any air bubbles using a squeegee (right), or by gently smoothing with your fingertips. You can take a break to allow the item to sit for about three hours, or you can speed up drying time dramatically for most projects by placing the transferred image and substrate under a fan or by using a hair dryer on a low setting. Generally, this takes about 5–10 minutes. You can finish with an oil-based polyurethane, if desired.

If you don't want to use Lazertran transfer media, you can also place images on wooden substrates by making a print using basic bond paper with a laser printer or photocopier. Then spray acetone, Xylol, or Citra Solv onto the wood before laying the printed image face down on the substrate to transfer your image. Burnish the back of the bond transfer paper with a metal spoon or bone folder, which is a tool made of bone or plastic that is used for creasing and folding when making origami. This is the basic process that artist Jake Atkinson followed to make his wooden box shown to the right.

Photo © Kim Kernehan.

Note: To facilitate the process when using an inkjet decal, you may need to apply a little glue or brush the wood with a small amount of turpentine before applying the image; but be careful, too much might dissolve the decal.

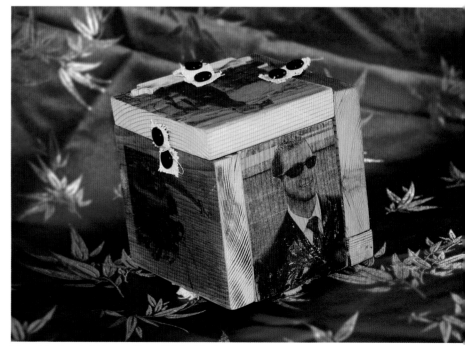

Artwork by Jacob Atkinson. Photo © John Neel.

Glass Substrate

I had a glass vase that I thought would look good with a photo on it (right). Here is how you can place an image on a piece of glass like that. We'll also look at additional methods for transferring to glass on pages 116-123.

Step 1: Flip an image in your image-processing program before making a print of it on a Lazertran Waterslide Decal with a laser printer or photocopy machine. This is because the decal will need to be placed face down onto the glass surface, thus producing a reversed image.

Step 2: Again allow the print to dry and then cut the white borders and place the Waterslide Decal transfer paper with the image in warm water for 30 seconds.

Step 3: Remove the Lazertran from the water, but this time keep the backing attached as you place the decal face down on your glass substrate. After you are satisfied with the Lazertran placement on the glass, remove the backing paper, thus leaving the image adhered to the substrate. Remove bubbles as prevously described. You can gingerly wash away any gummy substance that may remain on the back of the decal.

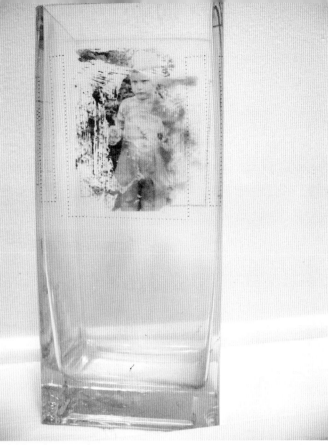

Childhood Revisited.

Step 4: The final step is to place the object in an oven on the bottom rack. Set the oven to a low but warm temperature (I usually start at about 125° Fahrenheit (52° C) for at least one hour to dry it. Gradually increase the temperature over the next hour or so until the decal becomes shiny like a glaze, then allow the object to cool. Slow the process if you find the decal starts to bubble. I generally increase the temperature from 125 to 225° F (107° C), and then up to 350–400° (175–205° C). I let it cool for about an hour before removing it from the oven because the glass may crack if you remove it too quickly.

After baking, if any gum has remained and turned brown, it can be removed with hot soapy water. The decal will be permanent.

Hint: Slightly heat the sheet of Lazertran with a hair dryer to make sure the toners are completely fused on the paper before cutting and soaking in water. This will avoid small air bubbles later.

Silk Substrate

In this instance, artist Kim Kerne-han manipulated lettering in Photoshop and reversed the type, printing with a laser printer onto long, narrow sheets of Lazertran Silk specialty paper.

Step 1: After printing on Lazer-tran Silk transfer medium using heat-based reproduction, put the transfer medium print-side down onto the fabric and iron the backing until you feel some resistance as the Lazertran starts sticking to the silk. Make sure to place a clean cloth be-tween the Lazertran's backing and the iron to protect the iron's surface as well as the silk substrate.

Step 2: Place the fabric with the ironed-on transfer and backing still attached into a tub of water (top right). Note that the backing paper is facing up after the ironing.

Step 3: Remove the backing paper when it begins to slip away from the fabric, revealing the images that imbue the silk scarf (middle right).

Step 4: Finally, squeeze excess water from the fabric and place a clean cloth over the images. Iron over the cloth to burnish the images, permanently fixing the Lazertran Silk paper images into the fabric.

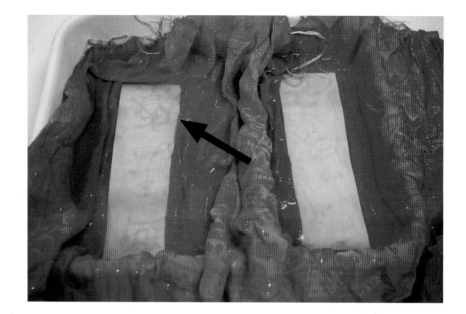

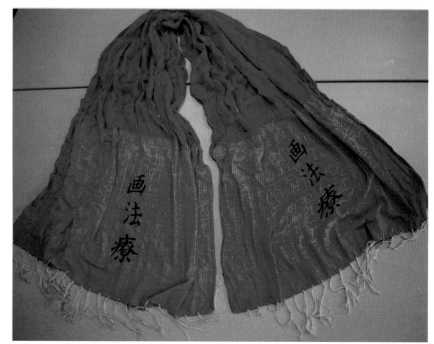

Artwork by Kim Kernehan.

Copper Substrate

Artist James Albertson had an idea to fashion a box using acetone solvent on copper (right). His method is a good example of experimentation. Because the copper was slickly polished, it was difficult to get just the right amount of acetone on it to create the transfer. James discovered that spraying the copper directly would not work, so instead he sprayed the acetone onto the back of the laser-printed photocopy paper. He placed the laser print with the toner side against the copper and applied pressure while burnishing the damp back of the paper, a procedure that succeeded in transferring the image to the copper substrate.

Artwork and photo by James Albertson.

A tape transfer image baked on Plexiglas by Colleen Familo. Note that you should be in a well-ventilated area anytime you bake tape transfers onto Plexiglas. Photo © John Neel.

Clear Packaging Tape

I like to transfer images from my computer onto clear packaging tape because these transfers can be used in so many different types of art projects. The versatility and creative potential is inspiring. I find a heat-based toner process produces the best result.

Step 1: Print either a black-and-white or color image—regular bond paper will work just fine for this. If you print in black and white, you can add color or make marks with Prismacolor pencils. Carefully cut out the printed picture.

Making Soap-and-Turpentine Ink

As always, I urge you to never stop experimenting with materials or methods: the sky's the limit in what you can accomplish. For instance, everyday bar soap combined with turpentine makes a kind of ink that serves as a very interesting transfer aid. This costs pennies to make and, using an inkjet printer for output, the results can be stunning on such surfaces as paper, fabric, and even wood. I like to use watercolor paper or vellum paper as my substrate. Not only do I love the artistic results, but I thoroughly appreciate the olfactory results as well, since the Ivory soap lends a clean scent to the substrate once it dries.

Make sure to have measuring utensils handy, a grater for the soap, and jars in which to mix the ingredients.

Self Portrait by Bryan Darby. The homemade recipe for a soap-and-turpentine ink acts as a transfer agent to print from bond paper onto vellum.

Note: Let me take the opportunity at this point to remind you once again—and this is something to keep in mind for most transfer processes—that if you are using text in your art, you will want to reverse the image using your computer image-processing program. This is also true if you want your images to appear exactly as you would see them in a photo, e.g. not reversed.

Cardinale's Grocery 1, Waterloo, NY. This is a photo after I processed it in ArtMatic. Note that the text is reversed as well as the image I then used my homemade ink solution to produce copies of this image.

Cardinale's Grocery 2, Waterloo, NY. Here is the image after it has been transferred onto vellum paper. It is now "unreversed" and the words can be properly read.

Step 1: Use the following recipe: Combine two tablespoons (10 ml) of soap flakes (Fairy Snow, Ivory Snow, or bar soap gratings) and 1/4 cup (60 ml) of hot water in a small jar. Stir until dissolved. Add one tablespoon (5 ml) of turpentine—don't use the same tablespoon you use for cooking! Let this transfer ink cool before using or putting the lid on the jar.

Step 2: Select an image and print with regular bond paper using an inkjet printer. Avoid using an image that has been printed weeks or months prior.

Step 3: Use a paintbrush to apply the soap/turpentine ink over the picture to be transferred. It is very important to brush the transfer ink directly onto the image side, not the back of the print.

Step 4: Wait 10 seconds. Place the photo face down on your chosen substrate and burnish with a blunt tool or the back of a spoon, just like you have done with the preceding transfers. Voila, you have a really cool image, like the one you see to the left.

After you have made a batch of this transfer ink, you may store it unrefrigerated indefinitely. If the ink solidifies, just bring it back to a liquid state by placing the jar in a pan of heated water or microwave. And don't toss out that byproduct transfer bond paper! You can scan the residue image back into your computer for further manipulation.

Gallery

Don't be limited to printing on paper. Use the methods described here for a variety of substrates, or use your imagination and experiment with new techniques and different substrates to transform your photos and prints into new artworks.

This wide-angle photo made from a homemade lens (DIY) was transferred to vellum using soap-and-turpentine ink.

Childhood Revisited. An image originally produced by using the Seksten method has been reproduced and transferred to wood using a Lazertran Waterslide decal and laser printer.

This portrait used acetone to transfer onto rawhide. Artwork and photo by James Albertson.

Len-it and Me. A wonderful example of the soap-and-turpentine ink transfer onto Vellum

A Few More Ideas

So as you can see, the possibilities for printing and transferring images onto all kinds of different substrates are endless—just let your imagination soar. And in case you are game to experiment a bit more, here are a few additional ideas:

Freezer Paper

• Iron your fabric to the shiny side of freezer paper, in a size that will fit in your printer. The heat from the iron will cause freezer paper to adhere to the fabric. Then run fabric/freezer paper sheet through your inkjet or laser printer. Thin fabrics seem to work best.

• After the image is printed on the fabric, iron the fabric side using a low to medium heat setting. Be certain to use a pressing cloth or release paper between the iron and the fabric image, so the freezer paper won't stick to the iron by mistake. Then peel off the freezer paper.

Gloss Gel Medium

• The basic process involves a reverse-printed image from your inkjet or laser printer, or a photocopier. So reverse the image in your image-processing software before outputting onto bond paper.

This muslin print was made using freezer paper to help pull the fabric through the pinter.

• After printing the image, brush it with an acrylic gloss gel medium. Also paint a layer on the surface where the image will go (fabric, cardstock, etc.).

• When the gel is fully dry, place the print face down onto the prepared surface of the substrate. With a nonstick pressing cloth on top of the face-down image, use a medium-hot iron. Peel the paper print off of the substrate when it has cooled.

• Use a soft, damp towel or wet your fingers to rub off any pieces of the paper that remain within the transferred image on the substrate.

Use care, because rubbing too or vigorously may remove some of the image. However, if the image gets worn in this way, it can create a nice antique look. To remove all paper residue, use a little olive or mineral oil and rub it on the paper pieces that have remained adhered to the substrate. Laser printers and photocopies have more permanent inks, so are less problematic when using this method.

The artist used gloss gel to transfer a photocopied image onto canvas and enhanced with paints and rubber stamps. Artwork by Patt Scrivener.

Note: The shiny quality of a gloss gel medium can sometimes detract from your finished product. If so, you can seal the image with a matte gel to give a duller look. Be aware, however, that matte gel does not work as well in the actual image transfer process as the gloss gel medium. So, use the gloss gel medium for the transfer of the image and then seal with a matte gel finish if you want to diminish the glossy look.

Iron-On Mending Tape

• Use iron-on mending tape (available at fabric stores) with an image printed on bond paper from a laser printer. Iron the tape onto the image using a fairly high (wool) setting with no steam for about 30 seconds. Do not apply pressure during the ironing.

• Peel the tape off immediately. This should transfer the image to the tape. If you wait until the tape has cooled, the paper may remain stuck to it. If it's too cool, reheat and peel. This takes some trial and error.

• Place the tape onto the fabric that you want to receive the image. Iron again, but this time at a higher setting (generally cotton works well) for at least 30 seconds. Do apply pressure this time.

• Peel the tape off while the image is hot. It is not always easy to control exactly how the image will reproduce, but the process is interesting and yields arbitrary and varied effects.

inkjet transfers

Chances are that you have an inkjet printer in your home. I have one, as well as a laser printer (more about that in the next chapter), and I use both for my image transfers since there are specialty papers manufactured for each type of printer. But some specialty papers, like Sheer Heaven, are designed especially for inkjet output. And some transfer techniques, such as the Seksten and Healey methods, as well as the process that utilizes an ink solution made of soap and turpentine, are effective only with transfer media that come from inkjet printers. Let's delve into some of the specific methods designed for using your inkjet printer to create heavenly photographic images.

Artwork by Colleen Familo

THE JOKER

The United States
Playing Card Company

CINCINNATI, OHIO

Costa Rica. A scenic photo transferred onto vellum paper using Sheer Heaven.

Sheer Heaven Transfer Material

Sheer Heaven is a versatile transfer material that makes beautiful, ethereal inkjet prints. It is a mid-weight, translucent, synthetic sheet that has a "tooth" etched into one surface. This means that, unlike other synthetics, Sheer Heaven is absorbent enough to be used for watercolor, silk dyes, acrylics, and even oil paints. No amount of moisture will warp, wrinkle, or tear the sheet. You can dye Sheer Heaven and it will dry perfectly flat. And for dry media, like colored pencils and pastels, the tooth on Sheer Heaven holds much more pigment build-up than bond paper, and the tooth does not flatten.

Yet here's an interesting fact: For Sheer Heaven's current usage as a medium to transfer images to another substrate, it was created by accident! The happy circumstance occurred when artist Jessica Isolek innovated a handmade paper that would be both heatproof and waterproof to underline the lampshades she was creating at the time. Five years later, one of her customers discovered that spraying the paper with 70% alcohol released the printed inkjet image and voila, the transfer paper was born!

Materials Needed for Sheer Heaven Transfer

- Sheer Heaven paper

- Inkjet printer

- 70% isopropyl rubbing alcohol (do not use 90% or ethyl rubbing alcohol)

- Spray bottle (for the alcohol)

- Burnishing tool, such as a bone folder or spoon

- Porous receiver surface (the transfer technique won't work on non-porous surfaces; the ink cannot sink into the substrate and will blur)

Some of the substrates I have used successfully include watercolor paper, print paper, absorbent card stock, muslin fabric, ultra suede fabric, balsa wood, tissue wrapping paper, handmade papers, journal pages, and bisque fired unglazed tile.

Bryan. This colorful portrait was enhanced in Studio Artist, output on Sheer Heaven, and then transferred onto vellum paper.

This paper lives up to its name most of the time, but not always. For example, since Sheer Heaven is manufactured for use with inkjet printers, I thought it would work seamlessly with any inkjet. I found that loading sheets into a recent top-loading inkjet printer produced excellent results; however, much to my dismay, when I tried using the medium in an older front-loading inkjet machine, the sheets would stick on the rollers and fail to curve through the printer. The good news? I found that if I peeled the sticky strip from the edge of an inkjet transparency sheet (used for the Seksten method, pages 86-91) and adhered it to the leading edge of a sheet of Sheer Heaven, it would feed through the older front-loader just fine.

Step 1: Make an inkjet print copy onto a sheet of Sheer Heaven paper, making sure that you print to the rough, suede-like side. (You can print on Sheer Heaven paper at any time and save the print—you don't need to transfer the image to your substrate right away.) Once again I remind you that an image will appear reversed whenever you make a print that will in turn be transferred to your substrate, so first create a mirror image if required (especially if there are words in your image) using your image-processing program.

Step 2: Holding the Sheer Heaven paper flat and parallel to your work area, spray the printed image with rubbing alcohol (70%), covering the area with a light mist. The sprayed surface should appear glossy, not saturated or runny. Angling the paper underneath a strong light should show if the image is covered evenly.

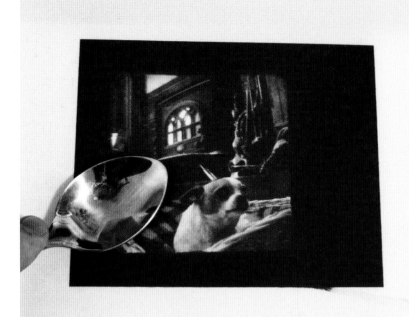

Step 3: Place the alcohol side of the Sheer Heaven print down onto a porous substrate such as watercolor paper or vellum. The alcohol on the surface of the Sheer Heaven paper makes it slightly tacky, so the paper will adhere to the substrate. Burnish the print with a bone folder or the back of a spoon, or another similar tool. The better the contact with the substrate, the more perfect the image transfer (top right). You will notice the Sheer Heaven paper has a translucent quality when placed on top of the substrate.

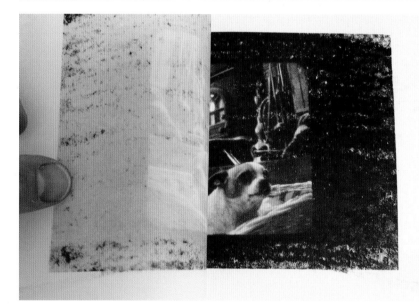

Step 4: Lift the Sheer Heaven transfer from the substrate (middle). Notice that some ink may remain on the Sheer Heaven (bottom). This byproduct of the process is called a ghost and can often be augmented to produce a completely different outcome, creating an interesting piece of art itself.

All photos above © John Neel.

Hint 1: If you missed a few
spots in ink coverage, you
can realign the Sheer Heaven
transfer back onto the sub-
strate and burnish it again
until the image fully transfers.
If needed, you can re-spray
the Sheer Heaven with the
alcohol solution to repeat the
application and burnishing.

Hint 2: Transfers are quick to
dry and non-sticky. You can
even transfer additional Sheer
Heaven outputs onto your
substrate, thus building up
layers of images.

Hint 3: The byproduct ghost
can be scanned to create
more digital art, or used with
other products to make beau-
tiful, one-of-a-kind creations.

Hint 4: An opaque white
residue around the transferred
image will show on dark-col-
ored papers or substrates. To
minimize this effect, trim away
excess Sheer Heaven around
the printed image leaving
enough on one side to hold
without getting your fingers in
the ink.

Hint 5: You can heat set the
image on the substrate with a
blow drier and then paint over
it and/or embellish with other
art materials.

Discovering a New Technique with Sheer Heaven

As an experiment, I printed the Sheer Heaven paper using a laser printer. This experiment was unsuccessful when I used the 70% alcohol. So, I decided to try the solvent Xylol and sprayed it lightly on the Sheer Heaven (acetone or Citra Solv will also work). I then transferred the image as described on the previous page onto the substrate. The density and color transfer was highly successful (and in some instances the byproduct by itself was stunning). Artist Kaitlyn Darby's lovely street scene below is an example of this technique.

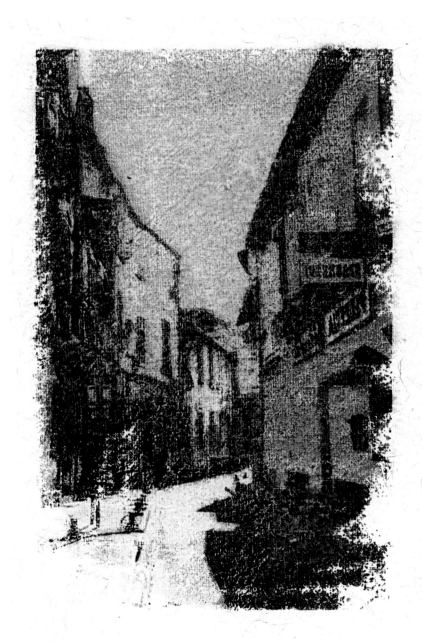

Europa; photo © Kaitlyn Darby, artwork by e.g. horovitz.

Gallery

The Sheer Heaven transfer medium reproduces images with a delicate, luminous quality that results in dreamy images, particularly when transferring prints to high-quality vellum or art papers.

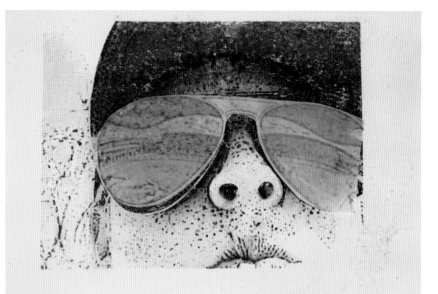

More Perspectives; photo © Kaitlyn Darby, processing by e.g. horovitz. Sheer Heaven byproduct in the sunglasses area placed on top of the image that has been transferred onto vellum.

Orchid 1. A picture of an orchid transferred with Sheer Heaven onto vellum. It was then cut out and sewn onto the by-product sheet of Sheer Heaven that lies beneath to produce a 3D effect. Beads are sewn through the center of the orchid so that it can turn.

Costa Rica Doorway. Photo transferred onto vellum paper then embellished with cheesecloth.

A landscape photo transferred onto decorative paper. Photo and artwork by John Neel.

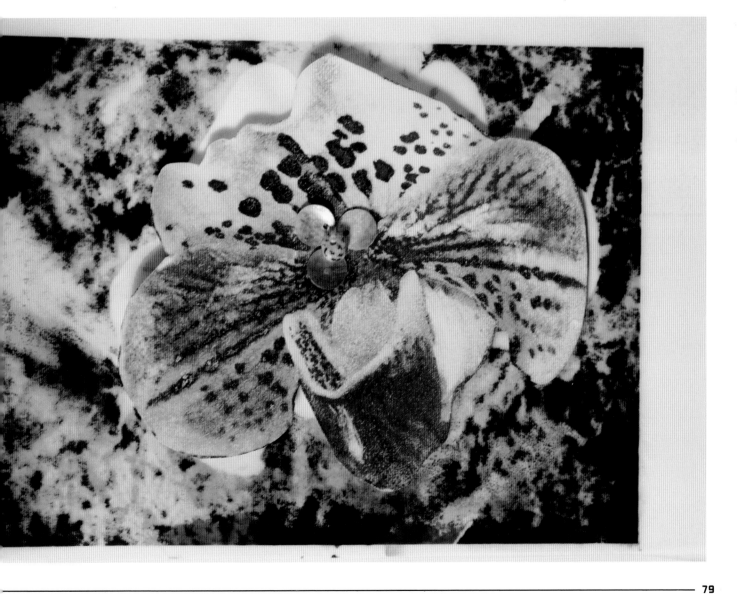

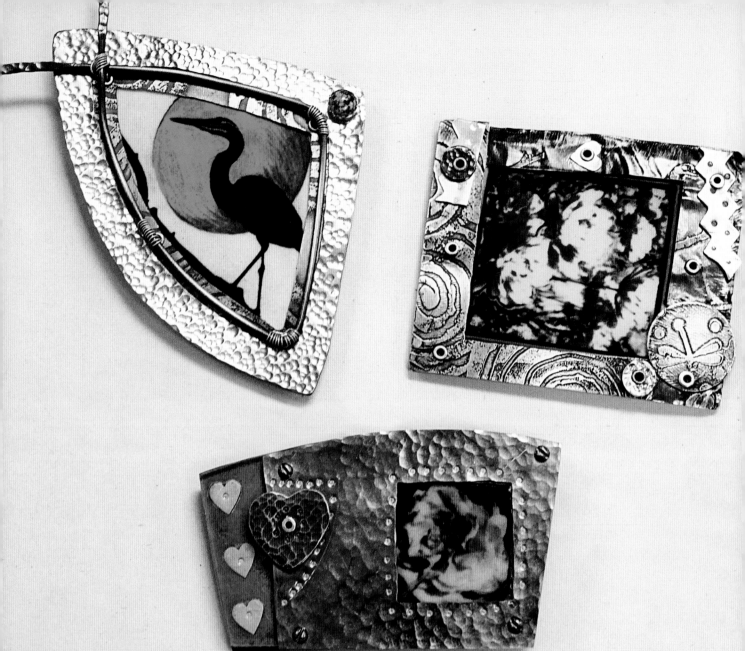

All art pieces by Lori Houlihan Higgins.

Grafix Shrink Film Basics

Text by Ellen G. Horovitz and Lori Houlihan Higgins

Grafix makes a number of art material products, including inkjet shrink film in clear and white, as well as a rub-on transfer film. Of course you can find more about different Grafix papers by visiting their website, but in this chapter I will examine Grafix shrink film for use in jewelry creation and cold connection jewelry. In particular, I will focus on Grafix white inkjet shrink film as an image transfer medium. The color reproduction and durability of this product make it useful and attractive for fine art jewelry applications.

Grafix inkjet shrink film can be printed on either side of the sheet using any standard inkjet printer—a wonderful innovation as it puts an end to the frustration of trying to figure out which side is coated for printing. Because shrink film actually does shrink, you should size the image anywhere from 50 – 60 % larger in your computer program than the intended image area on your finished piece. Additionally, it is a good idea to make several versions of the image with different color adjustments using your image-processing program prior to printing in order to balance the increased color intensity that results when shrinking occurs. Allow the film to dry for a few minutes after printing. The manufacturer suggests that the printed image be cut out of the printed film prior to baking. However, for the project described in this chapter, Lori Houlihan Higgins and I suggest you make use of a jewelry saw and a drill to make size adjustments after baking.

Grafix is shrunk by baking in an oven. This shrinking can also be done with a heat gun or embossing tool, but the final product becomes more difficult to control. Place the film on parchment paper, cardboard, Teflon sheet, or vellum before baking. Do not bake on bare metal or a baking stone.

The film will curl, shrink, and finally start to flatten as it heats. We recommend laying a sheet of glass on top of the warm shrink film as it is taken from the oven to aid in flattening. Another option is to lay cardboard on top of the image and use a brayer to flatten. Be careful because the film will be hot. There may be slight distortions in the image, but perhaps you can use such variations to your creative advantage.

The Grafix Process

After baking, Grafix inkjet shrink film becomes a hardened plastic material. It is particularly useful because you can utilize the end product in a variety of artistic projects. In addition to being an invaluable aid in creating beautiful, wearable jewelry, this film can help you create tags, embellish projects into wearable art such as buttons, or use with mixed media for other artistic creations.

Materials Needed for Grafix Shrink Film Transfer

- Grafix white inkjet shrink film
- Inkjet printer
- Jeweler's saw and blades, bench pin, bastard file, ball-peen hammer and punch
- Assorted 24 gauge sheet metals: copper, brass, and sterling silver
- Brass eyelets, metal tubing (with flaring tool), or cold connection screws

Additional Suggested Materials:

- Templates, metal scribe, steel block, small metal stampings, polishing papers, safety glasses and particle mask, epoxy glue and Permalac, pin backs
- Two hole punch or flexible shaft with drill bits
- Chasing tools

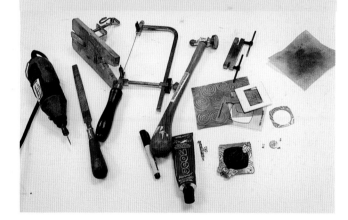

Step 1: Use an inkjet printer to output your selected image or design onto a sheet of Grafix shrink film. It is hard to predict the exact color intensity that will result when an image is baked and shrunk, so print several copies of the file at different color levels. Remember to print the image about 50 – 60% larger than your final usage calls for because it will shrink during baking. Experimentation is key and a big part of the appeal of this medium.

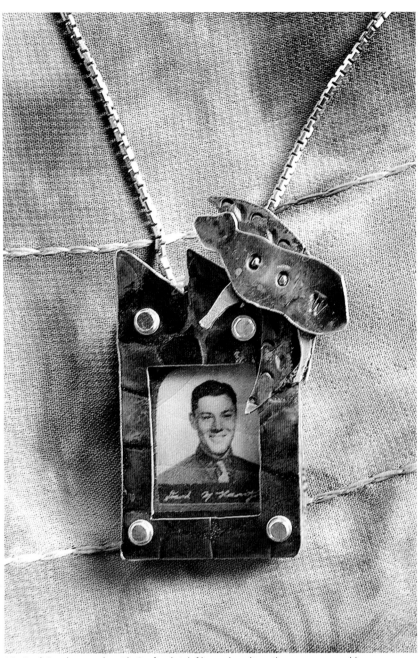

My Dad. Pendant made with Grafix shrink film and sterling silver, copper, and brass.

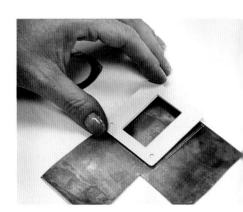

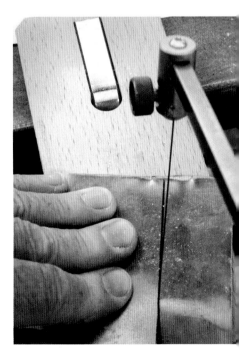

Step 2: Preheat your oven (toaster or regular) to between 300° and 350°F (approximately 150 to 175°C); we have found that best results generally occur from baking at 325°F (163°C). Bake the Grafix image from two to three minutes.

Step 3: After baking, lay the image aside for a few minutes. Using a template, scribe, punch, and saw, cut out the metal frame for your Grafix image (right). Use the bastard file to smooth both interior and exterior edges.

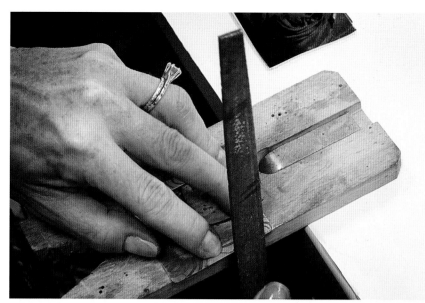

A bastard file is used to smooth interior and exterior edges of the metal.

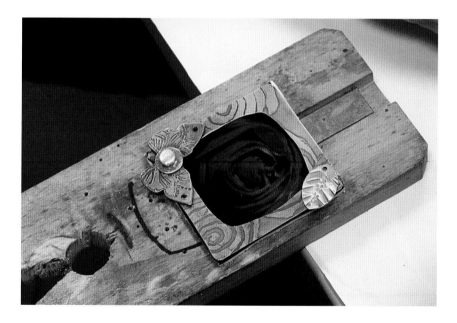

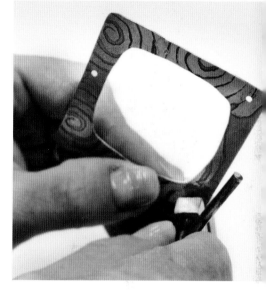

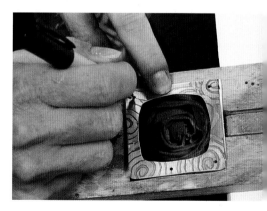

Step 4: Use a jeweler's saw to cut out the baked image to fit your project. Cutting after baking will give you much greater control of image size than cutting the film before baking. The baked Grafix is a thick and durable medium on which to work. The image of a rose was printed at dimensions of four by six inches on Grafix before it shrunk to a suitable size for a brooch after baking. It was then cut to fit the design of the brooch.

Step 5: Lay out the various metal elements for the brooch and arrange until you have a pleasing design (above). Materials for the brooch can be drilled and attached directly to the Grafix image.

Step 6: Mark the metal frame and use a two-hole punch to create holes in it (right top). Also mark corresponding holes in the Grafix (right bottom). It is critical that these holes are drilled, not punched, since punching may

crack the baked shrink film. Be careful to drill holes slowly as the material will melt with the heat of drilling action. The Grafix piece is strong and handles a drill very well, but is brittle if punched.

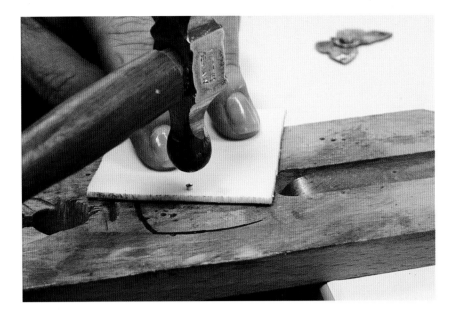

Step 7: Assemble the piece and attach with your chosen cold connections. Brass eyelets were used for this design. Using a ball peen hammer, lightly tap the rivets from the Grafix side to attach the Grafix to the metal components.

Step 8: Attach a pin to the back of the Grafix using epoxy. Seal the completed brooch with Permalac.

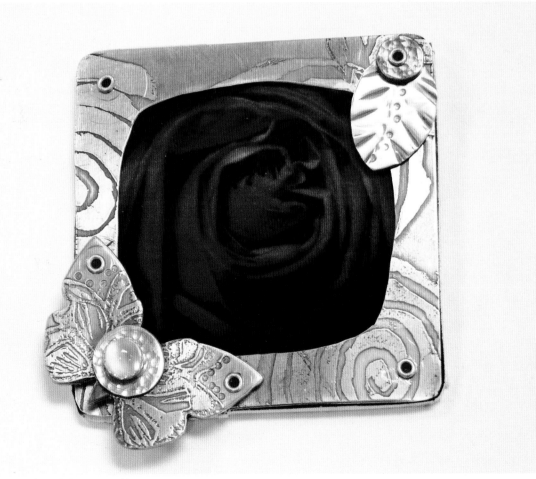

The final red rose brooch by Lori Houlihan Higgins.

Gallery

The strength and capacity for excellent color reproduction make Grafix white injket shrinkfilm an optimal material for transferring images to your jewelry creations.

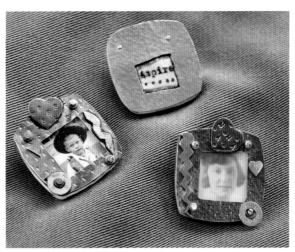

Top brooch created using Grafix with sterling silver by Lori Houlihan Higgins. The bottom two pieces are Grafix and sterling silver, copper, and brass with some soldering and cold connections/screw connections involved, both by e.g.horovitz.
Photo © John Neel.

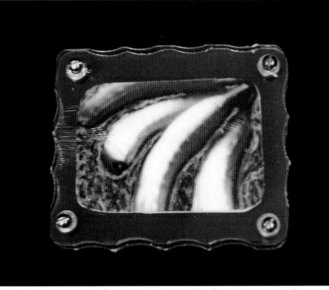

A Grafix output printed from analog image that had been scanned into the computer and presented with Lucite. Artwork by Lori Houlihan Higgins.

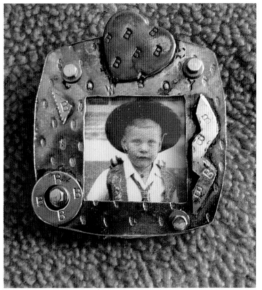

Cowboy. Grafix output under copper with sterling silver and brass, with patina.

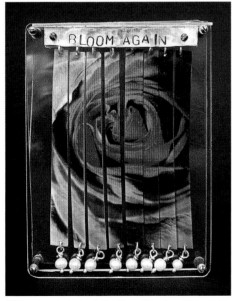

Bloom Again by Lori Houlihan Higgins. This multimedia shadow box produced using Grafix, Lucite, brass, pearls and sterling silver.

My Shayna Punim Siesta. Demonstrates another Grafix process on rock using the company's Rub-Onz Inkjet product, which does not need to be baked.

Cheesecake Mama. This photo was processed in both ArtMatic and Photoshop, then transferred onto vellum paper using the Seksten method.

The Seksten Method of Photo Transfer

My students are forever pushing the envelope. Sarah Eksten, a former student and fellow author in my latest art therapy book, formulated an original method of transferring that we aptly named the Seksten method (after Sarah, of course). Similar procedures have popped up on the Internet since, but this is a fun and effective technique that we have used for years.

Sarah's original idea was to combine an inkjet transparency paper with Mod Podge to obtain a nearly perfect transfer onto a substrate—one that resembles the negative transfer method achieved by the old Polaroid pull-apart films or, nowadays, with Fuji's FP-100 films that will be covered on pages 136-145.

Materials Used in the Seksten Method

- Photoshop, Gimp, or like software program to create multi-image PDF

- An inkjet printer, not a laser printer

- Mod Podge or gel medium to apply to substrate

- Inkjet transparencies

- Brayer, brush, and newspaper, etc. for clean up

Step 1: Start by creating a new 8-1/2 x 11-inch (21.3 x 27.9 cm) document (File ····⟩ New). Select Transparent as the Background Content and select 300 ppi for resolution.

Step 2: Open the images you intend to print. You can fit several images onto one sheet of transparency, depending on the size and dimensions of the image files. Copy each image onto the new document by selecting the Move tool and dragging the image onto the new document.

Step 3: Each image you move to the new document produces its own layer (see circled illustration, left). You can resize and reposition each image on the new document by highlighting its layer in the Layers palette and then going to Edit ····⟩ Transform ····⟩ Scale in order to reconfigure it to suit your needs.

Step 4: Once you are satisfied with the images in the new document, flatten the layers (Layer ····⟩ Flatten Image) and save the file as a PDF in preparation for printing.

Sunset. Image enhanced in Studio Artist and transferred onto marble vellum paper using the Seksten method.

Step 5: Insert an inkjet transparency into your inkjet printer so that the ink deposits on the grainy side of the transparency. Print a copy of the PDF file you have created. If you end up printing on the smooth side, the ink will neither stick to the transparency nor transfer to the substrate. However, if you do print on the smooth side, don't throw it away. You can still use it as a byproduct, as I will describe on pages 146-155.

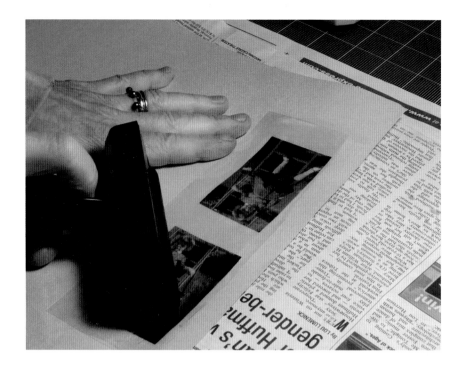

Step 6: Spread gel medium or Mod Podge (too little will not pick up the image; too much is a waste) with a sponge brush or paintbrush onto an absorbent substrate (heavy paper, wood, canvas, etc.; in the illustration above of the girl standing on a swing, I used a heavy vellum paper). Place the transparency image ink side down onto the gel medium or Mod Podge.

Step 7: Press the transparency into the gel, but be careful of pushing too hard or spreading it around on the substrate to avoid distortion of the image, unless that is the effect you are trying to achieve. Use a brayer with light to medium pressure while running over the transparency a half-dozen or so times, always in the same direction.

Step 8: Let the transparency lie on top of the substrate for approximately one to three minutes before carefully pulling it up. As you do so, some of the ink may remain attached to the transparency. Don't worry, this is often desirable since the image remaining on the substrate replicates the quality that is achieved by using instant film for transfer (see pages 136-145, though bear in mind that this method is about one-quarter the cost of using analog instant films). However, if you don't like the effect of missing ink, you can add a little Mod Podge or gel medium to the transparency and place it back down on your substrate.

Step 9: Next, embellish and finish the image with any added touches you desire. In the example to the near right, I used copper foil around edges to make a bookmark.

Don't throw away that used transparency byproduct! I find the misty color residue left on the inkjet transparency sometimes even more beautiful than the original transferred result from the Seksten method. So I took an extra step to let the byproduct transparency dry completely and then adhered its negative images onto the back of the bookmark with some more Mod Podge (far right).

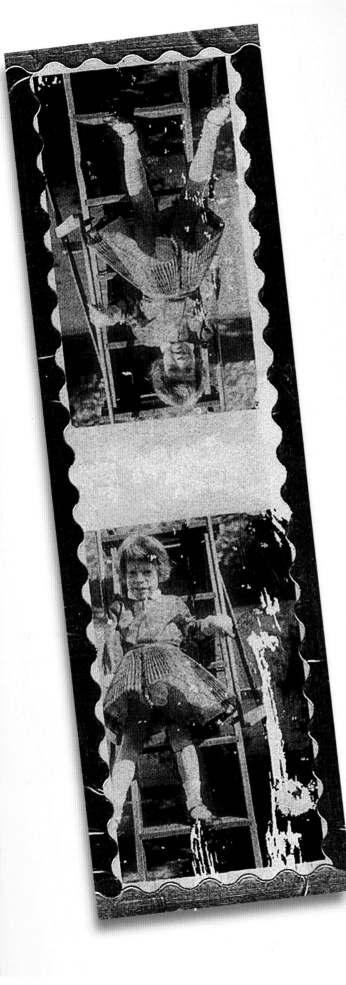
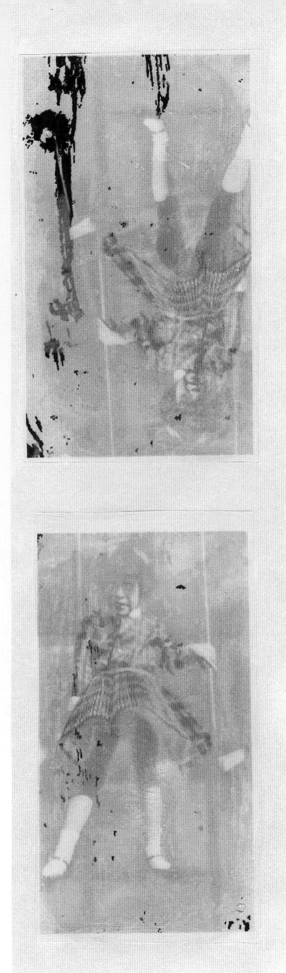

Gallery

The Seksten Method can be used with several different substrates, including fabric, cardboard, and even wood. I find it yields particularly beautiful prints when transferred to vellum or decorative art papers.

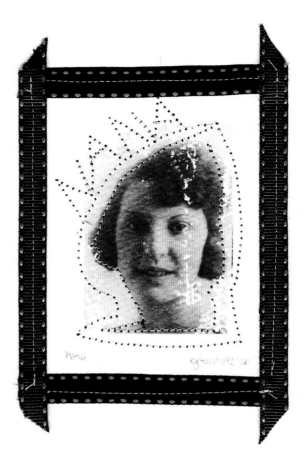

A bookmark using the Seksten method to transfer portrait onto watercolor paper, with sewn thread and ribbon.

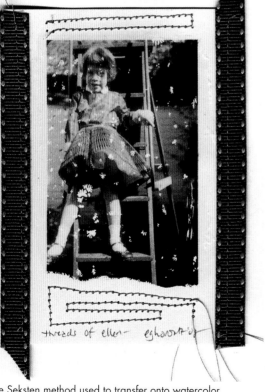

The Seksten method used to transfer onto watercolor paper, sewn thread and ribbon.

A Seksten transfer onto vellum paper with sewn thread.

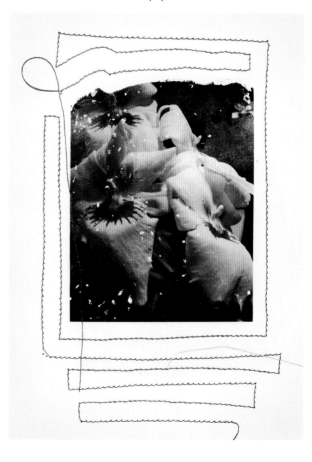

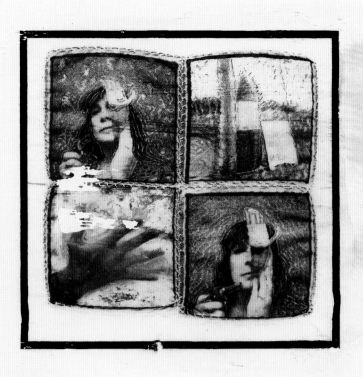

This series comes from instant film
images that were first output onto inkjet
silk fabric pieces and sewn together.
That was then scanned and re-output
using the Seksten method to transfer
onto vellum paper.

My son, Bryan, Drenched in Afternoon Light.
A Seksten transfer onto vellum paper.

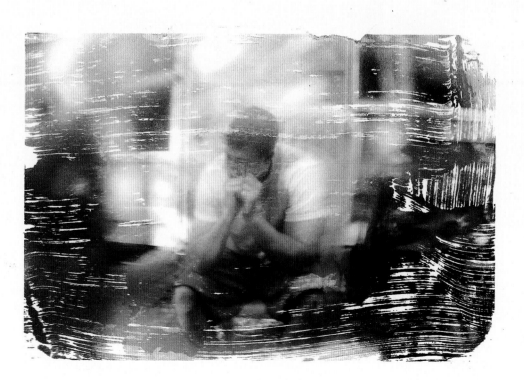

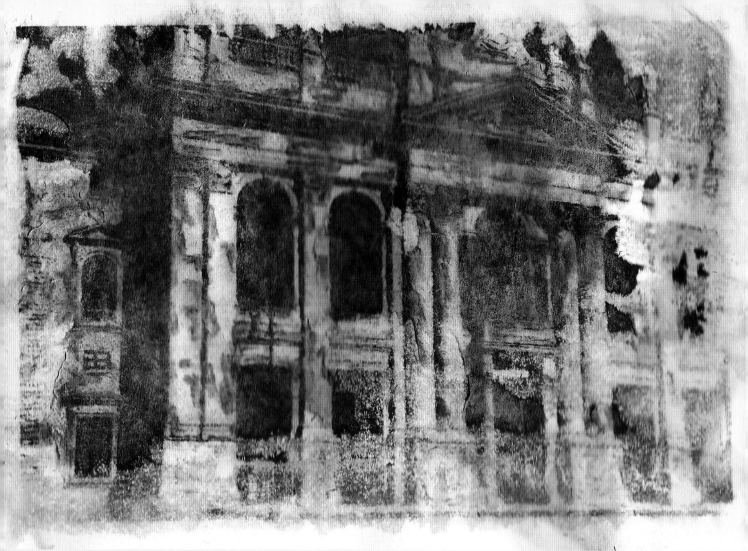

Italy, Version 3. © Image by Bryan Darby with manipulation by e.g.horovitz.

The Healey Method for Transfers to Paper or Fabric

This method was a happy accident created by my former student, Lisa Healey. She forgot one of the crucial steps outlined in class for following the Seksten method. So Lisa forged ahead with her project in a different way: In lieu of using an inkjet transparency, she printed her inkjet image onto regular bond paper. She then proceeded through the rest of the Seksten steps, but found the results were somewhat different. The bond paper transferred the image to the substrate, but due to the Mod Podge applied during the process, pieces of the bond remained stuck to the substrate in a random pattern as Lisa peeled it up. However, the image showed through those pieces of bond paper stuck to the substrate, due in part to the Mod Podge mixing with the inks. Thus, these fragments adhering to the substrate became part of the image, giving it a torn quality reminiscent of a negative emulsion transfer (see pages 140-141). It turned out to be quite an interesting form of image making.

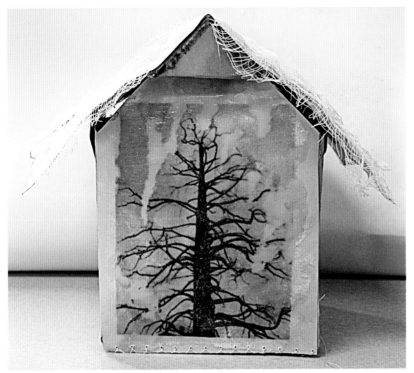

Artwork by Meghan Cowley.

Step 1: Find an image in your computer (or make a new PDF document combining several images) and reverse it in imaging software if necessary. Then output on bond paper using an inkjet printer.

Step 2: Cut the image out so that there is a small border around it.

Step 3: Brush a thin coat of gel medium or Mod Podge onto the substrate or the bond transfer sheet—it does not matter which way.

Step 4: Press the image face down onto the substrate and burnish it using fairly heavy pressure. Lisa used the handle of a pair of scissors, but any burnishing tool should work, including a bone folder or the back of a spoon.)

Materials Used in the Healey Method

- Gel medium or Mod Podge
- Somewhat transparent substrate: paper, muslin, cheesecloth, etc.
- Image or photo printed using inkjet printer on bond copy paper
- Burnishing tool

The key with the Healey method is to print your picture from an inkjet printer using plain bond paper and adhere it by placing gel medium or Mod Podge onto your substrate. Lay the bond paper with the ink side down onto the coated material (art paper or vellum works well). It is helpful if the substrates are both transparent and lightweight; that way you can better see what is transferring onto them as you burnish the image, allowing you to more handily control the outcome. While you might be able to use a more opaque substrate, the transparency of cheesecloth, muslin, and interfacing works particularly well. These materials are all readily available at sewing or fabric stores.

Step 5: As with the Seksten method, let the photo sit on the substrate for one to three minutes.

Step 6: When ready, slowly peel off the bond paper. With the aid of the gel or Mod Podge, the print will have transferred to the substrate. However, portions—sometimes large portions—of the bond paper will remain adhered, with the ink from the image on the substrate showing through, although less vibrantly than in those areas of the image where the bond completely peels off. The amount of bond paper that remains stuck to the substrate depends on several factors: The length of time the bond remains on the receiving image, the evenness with which the gel is spread on the substrate, as well as the method in which you peel up the bond paper. If the substrate tears as you peel up the bond, you can press the paper back down and burnish again (unless the rip is your desired effect and you wish to leave blank areas in the image). Just as in the tape transfer method (page 55), you can remove the portions of the bond paper that have remained on the substrate by rubbing them with wet fingertips after the image has dried so that the residue of the bond will ball up and come off.

Enhancing the Healey Method

Experimenting with the result attained with the colorful frog illustrated on the preceding page, I decided to enhance the image using cocoa (specifically, Swiss Miss). Naturally, this particular alteration was discovered because of a mistake. Late one night as I was planning to enhance an image with watercolor, I stuck my paintbrush into the cup of hot cocoa I was drinking instead of the nearby water cup, and I proceeded to paint the cocoa onto the image. The result was more than interesting, and gave me food (or drink) for thought on how to take further advantage of this effect. So I next misted my substrate with a 70% alcohol solution (as used in the Sheer Heaven method) each time before successively painting several layers of cocoa. I then coated the result with Permalac spray several times (actually about 20). This gave the image a permanent sheen and coating, as you can see above.

Note how the hue has been deepened by adding these layers of cocoa, as well as from spraying the alcohol solution on the image between each layer. The Permalac was applied to protect the image. The result is a stunning one-of-a-kind piece of artwork.

Enhancing the Healey method with cocoa, alcohol, and Permalac punches up the contrast and the color. It is akin to using such adjustments tools as Hue/ Saturation and Selective Color in your image-processing program. It is also similar to how painting with watercolor or watered-down acrylic produces heavier-than-normal contrast. Spraying the image with alcohol and Permalac gives the picture an additional quality that is not unlike that found in images recorded with analog instant film.

Gallery

The Healey Method gives reality a slight, subdued twist, as though seeing images through a film of gauze.

Aces by Colleen Familo. A Healey transfer onto another playing card.

f Box, Side 1
Lisa Healey.
Healey method
d with mixed
dia to make a
e of a cloth box.
isa Healey.

Lola Sleeps.

Olympic Walkway. The Healey method with some of the residual bond removed while some was left on the substrate to give it a worn look. Image by Bryan Darby and manipulation by e.g.horovitz.

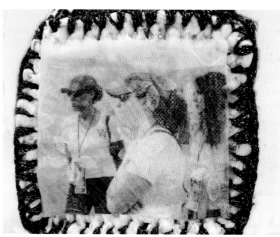

Self Box, Side 2 by Lisa Healey. Another side of Lisa's cloth box.

heat-based (toner) transfers

There are a number of transfer methods that require the heat-based technology found in laser printers and photocopy machines. Some substrates like glass, wood, and ceramic often need prints made with dry toner ink to successfully reproduce images, and heat-based transfers to fabric are often more permanent than those generating from inkjet printers. Several techniques using laser transfer media were discussed in Chapter Two, including laser printer paper and some types of specialty papers for use exclusively with toner. Additionally, heat-based transfer materials can be used with solvents such as Citra Solv, acetone, or Xylol on numerous porous substrates, particularly decorative papers, vellum, fabric, polymer clay, and liquid polymer clay, to make unique prints and artistic pieces for wear and adornment. If you do not have access to a photocopy machine or laser printer, local print shops can output your images so you can create these types of media and objects. So let's look at some of the products and solvents you will need for these techniques to create wearable art, functional artistic pieces, and unique projects.

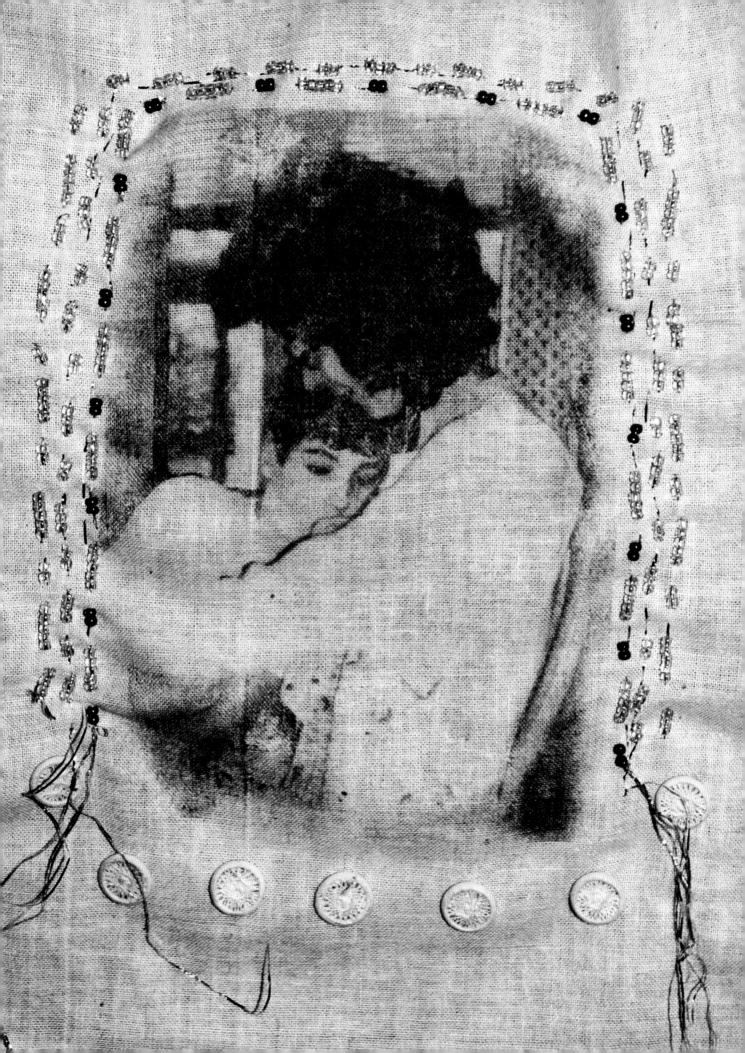

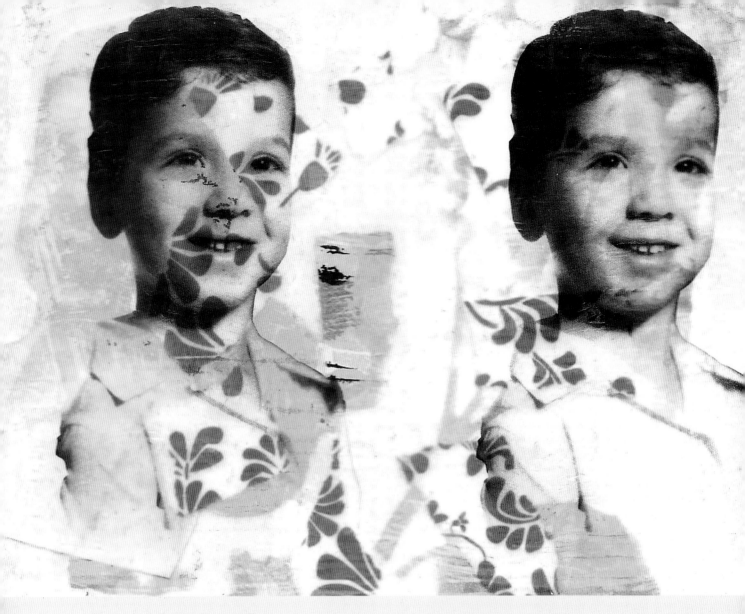

Using Solvents to Transfer Images

Using liquid solvents as aids to transfer heat-based reproductions is a common, relatively simple, and effective way to faithfully copy images onto a wide variety of substrates, especially onto paper and fabrics. It is also a much less expensive method than using specialty transfer papers such as Lazertran. Popular solvents used by artists include acetone and Xylol, but the most environmentally friendly is Citra Solv, a cleaning solution often found in the household aisle of large grocery stores.

You can use most types of liquid solvents such as acetone or Xylol in the same way you would utilize Citra Solv to act as an agent in aiding the transfer of your images. These liquid solvents are effective transfer agents when used with copies of images printed from a photocopy machine or laser printer, and you can output the image either as a color print or black and white. Any weight of paper will do, nothing more special than the stock you normally run through your copier or laser printer. If using a photocopier, you can choose to manipulate the image as described on page 47, or just use the photocopied print as is. If you don't have access to a photocopier and need to copy an image, you can use a scanner and then output with a laser printer.

Materials to Aid the Process

Here is a list of items you will need to start the transfer process using liquid agents. Remember to line your worktable with newspaper to prevent marring its surface.

- Citra Solv (or Xylol or acetone)
- A spray bottle for dispensing the liquid transfer agent
- Scissors
- Paintbrush
- Spoon to use as a brayer or Lineco Bone Paper Folder
- Photocopy machine or laser printer (heat-based toner required for transfer)

It is important to use acetone and/or Xylol in a well-ventilated area. I prefer Citra Solv because it requires little ventilation; though sold as a degreaser, it does not contain the noxious fumes of Xylol and/or acetone. Instead, it has a lovely orange scent. A bone folder or the back of a metal spoon works well for transferring onto various substrates. The scissors allow you to cut out the images and/or use in place of a bone folder for burnishing.

Using Citra Solv with Paper Substrates

Step 1: If the image you want to transfer contains words or needs to be reversed for any reason, flip it in an imaging program before making the print. Output your image using a laser printer and/or a photocopy machine.

Step 2: Lightly spritz Citra Solv (preferred, but this is where acetone or Xylol also work) onto your receiving substrate (this should be relatively heavy paper, like a cardstock—or vellum finish 65 lb. paper). Then place the photocopied (or laser-printed) image face down onto the damp paper substrate. Burnish by rubbing the back of the copy as it lies on the substrate (below). While burnishing in this way, the image begins to show through the backside of the facedown photocopy paper. Alternatively, you could place the laser print onto the heavier substrate and use a brush to wet the back of the printed image and then burnish.

Step 3: When satisfied after burnishing, lift the laser-printed image off and let your newly imprinted substrate dry.

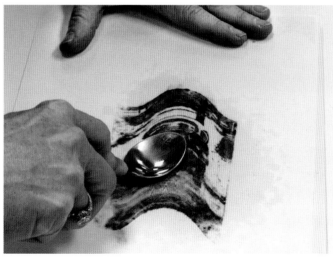

Photo © John Neel

Transferring with Citra Solv to Fabric

The image used in these steps is of my beloved father who was in the Air Force during WWII. A vintage photo of him in front of his buddies was scanned into my computer and then printed with a laser printer using regular bond paper. The final finished image on muslin, right, permanently imprints a wonderful memory.

Step 1: Take the laser print and use straight pints to adhere the image face down to muslin or whatever fabric you are using as a substrate (right middle). This helps prevent the print from sliding around when applying the Citra Solv and burnishing the image onto the cloth. Use a brush or spray bottle to apply Citra Solv on the backside of the paper containing the image. At this point you should see the image clearly showing through the backside of the paper.

Step 2: As you did with a paper substrate in the previous section of this chapter, burnish the image into the cloth using steady pressure moving in a rounded motion (right bottom).

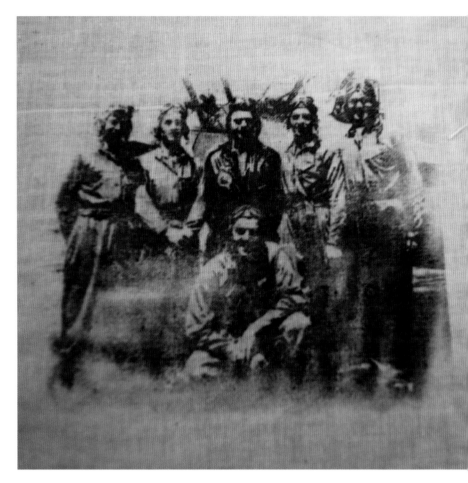

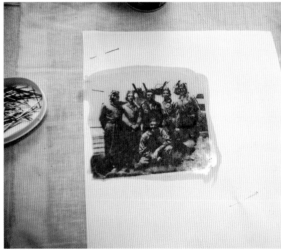

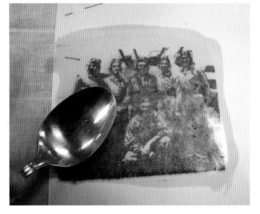

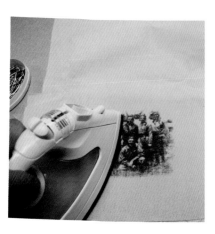

Step 3: Remove the paper to reveal the image on your cloth. Let it dry for a few minutes.

Step 4: Burnish the image further into the fibers by ironing the fabric onto which the image has been transferred (above). You can use another cloth on top of the image to protect it, or iron with a medium setting directly onto the fabric. Let the work dry for 24 hours before washing. While you can wash this with traditional laundry detergent, I prefer Woolite or non-phosphorous laundry detergent.

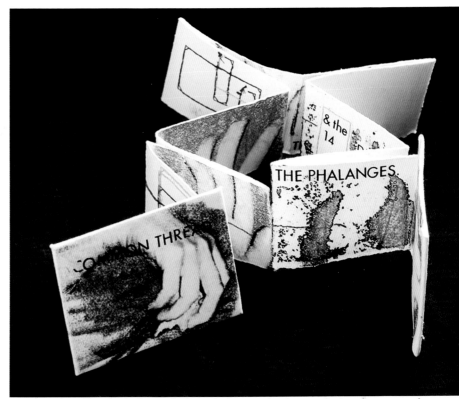

Common Thread by Elizabeth Brandt ElBayadi. A unique book created using acetone transfer.

Making a Handmade Book Using Acetone

To produce the unique book seen above, artist and former student Elizabeth Brandt ElBayadi started by recording several digital photos of her hand. She then printed each photo on regular photocopy paper using a laser printer. Next, Liz transferred the images onto handmade paper using acetone instead of Citra Solv, and then hand-colored each. Finally, she hand-stitched all the substrate pages together to form a book about the hand and all of its functions.

This book is a beautiful one-of-a-kind creation called *Common Thread*. It is not only about the anatomy of the hand, but also about the hand's functions from art to love. This treasured gift, given to me by Liz, is a daily reminder of how much we share, influence, and impact one another in life and our continual quest for commonality.

Step 1: Preheat your toaster oven to 260 – 275° F (127 – 135° C) and pour the Liquid Sculpey onto a glass surface that will fit into your oven (right). It helps to pour the Liquid Sculpey evenly and make a template a little larger than the size of the image that you intend to transfer. Here I have printed out the same image using a black and white Laser print as well as a color Laser print

Step 2: Place the photocopy gingerly on top of the Liquid Sculpey in such a way that you don't dislodge it (below).

Step 3: Allow the image to rest on the Liquid Sculpey. After a few minutes, you will begin to notice the image leaching; the image will begin to appear on the backside of the paper (opposite top). Generally 5 – 10 minutes is long enough for the image to leach into the Liquid Sculpey.

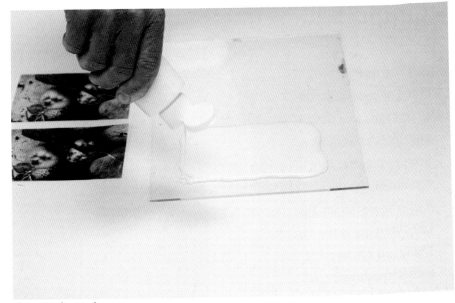

Photo © John Neel

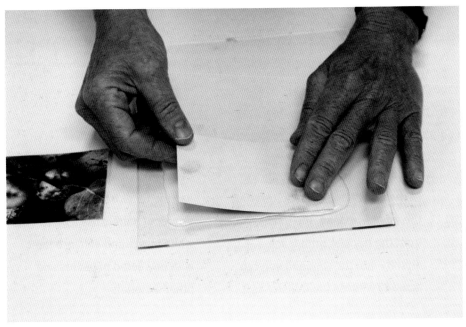

Photo © John Neel

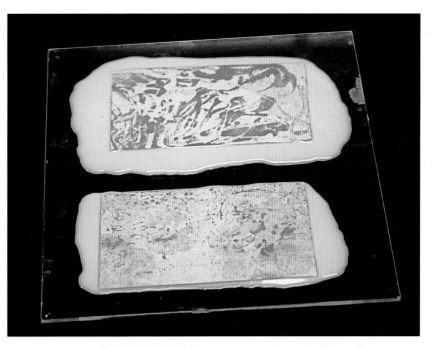

Step 4: Bake for approximately 15 minutes by placing the glass, Liquid Sculpey, and laser-printed photo in the oven when it has reached the preheated temperature.

Step 5: Carefully remove from the oven using oven mitts. In some instances the paper already begins to curl at the corners, allowing you to lift it off easily. If not, use an craft knife to very gently pry the edge of the paper up and then peel the paper back to reveal the design impregnated in the Liquid Sculpey (right). The peeled photo prints can be salvaged to be reused for further manipulation (in software programs through scanning) or as byproduct art.
The resulting image on the now-baked Liquid Sculpey is wonderfully flexible, as illustrated in the bottom photo (right). It can be cut, sewn, folded and /or manipulated in this form, becoming much more pliant and elastic than standard polymer clay.

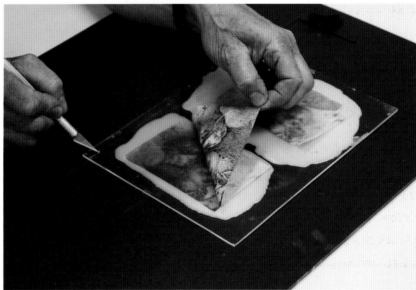

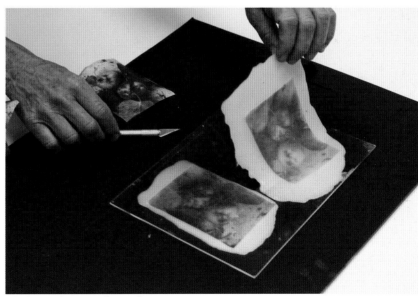

All photos above © John Neel

Gallery

Polymer products (such as Premo Sculpey and Liquid Polymer Clay) are great substrates with which you can make long-lasting artwork and fashionable jewelry.

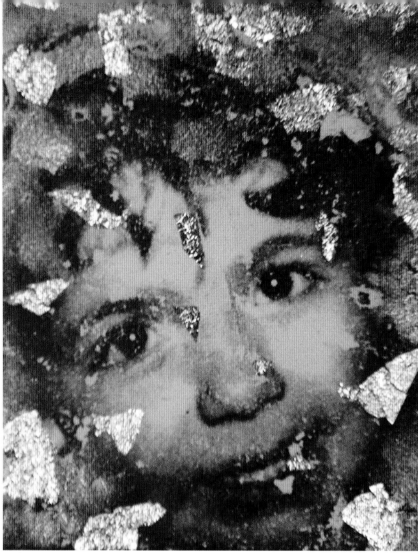

Sculpey polymer clay decorated with gold leaf and Jacquard pearlized powders. Artwork by Jennifer Naumovski.

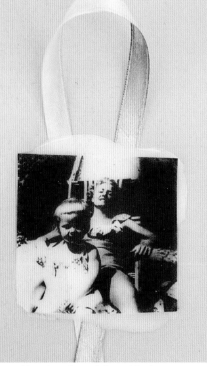

Mixed media with Liquid Sculpey. Artwork and photo by Barbara Murak.

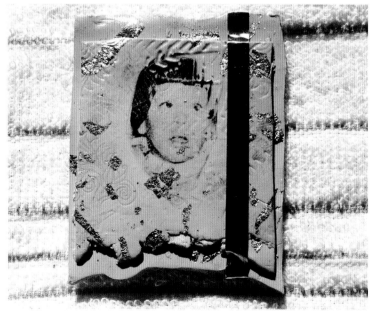

Wonder. A mixed media magnet transferred to Sculpey polymer clay, adorned with copper foil, copper leaf, and 24-karat gold leaf.

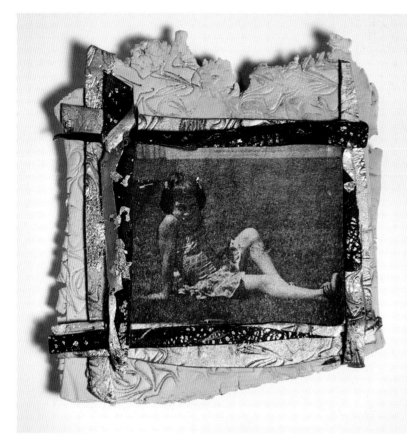

Nancy. Jacquard powder pigment, rubber stamps, as well as copper, gold and silver leaf embellish this piece of Sculpey polymer clay.

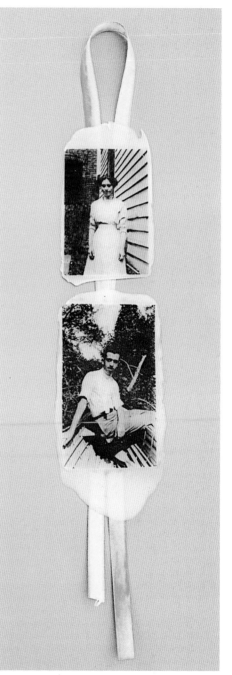

Mixed media made with Liquid Sculpey. Notice it is translucent enough for the ribbons to show through the artwork. Artwork and photo by Barbara Murak.

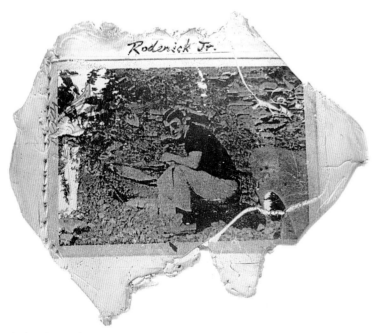

Sculpey polymer clay embellished with Jacquard pigment powders. Artwork by Roderick Castle.

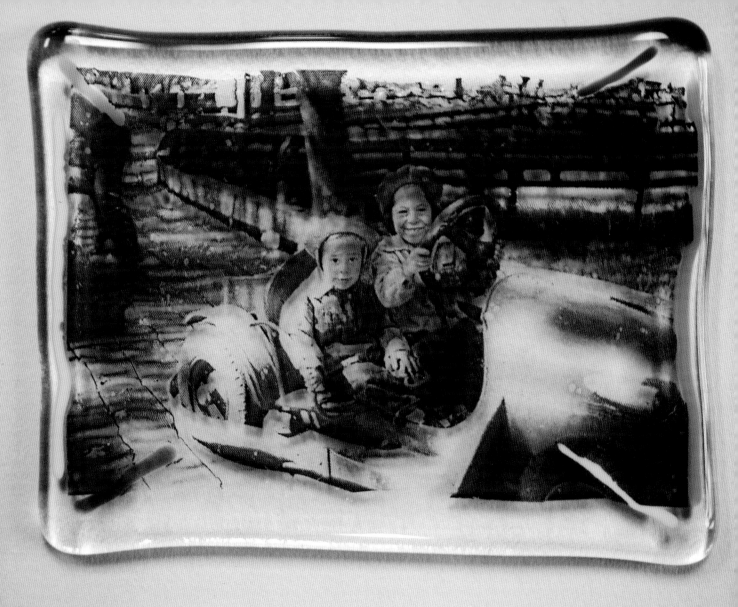

Lenny and Nancy at Roger Williams Park. A black-and-white photo fused onto glass. Note that when the image is fired, it changes to a sepia hue. Using colored glass, colored frits, or other supplies offer novel effects.

Photo Fusing on Glass

Historians generally agree that artisans have been fusing glass for nearly 4,000 years. Today, fusing photographs in glass can create a keepsake to treasure for years to come. This interesting technique of using special paper, a laser printer, and a kiln to create permanently fused images onto glass items has numerous artistic applications.

The process is fairly simple and can be used with almost any photograph, though black and whites are recommended because of the concentration of iron oxide found in the black toners usually used in laser printers. The toner needs to be high in iron oxide to withstand the temperature of the kiln. You can convert color photos to black and white on your computer using image-processing software as explained on pages 12-15. For the glass projects described here, artist Brenda Cunningham—who did much of the research for this section—and I used the HP Laser Jet series 4240/4250/4350 printers.

Materials Used for Photo Fusing

There are many different types of glass available with variable properties depending on the specific recipe used to produce them. You will want to use pieces of glass that have been manufactured with the same capability to withstand very hot kiln temperatures. In other words, they must have compatible Coefficients of Expansion (COE). This includes sheets of clear or colored glass, frits (granulated pieces of glass), and stringers (rods of glass that come in several colors and thicknesses).

- Fusing photo paper for a laser printer (Delphi Stained Glass Supplies is the source for images used in this chapter)

- A laser printer that uses black toner with high iron oxide content (most HP models will work)

- Distilled water

- Shallow tray for the water

- Fusible sheets of glass (COE 96). We used clear, but color is acceptable depending on your preference

- Optional (all COE 96): various colors of glass frit (we used fine, but larger sizes would work), various colored glass stringers (we used a Mardi Gras pack; there are also thicker variations called noodles that also are acceptable)

- Glass cutter

- Scissors, running pliers, ruler, sharpie marker

- Small squeegee (optional)

- Paper towels

- Kiln. We used a 12-sided Paragon Janus Multi-purpose kiln with a Sentry 2.0 controller. Kiln schedules will vary depending on the type of kiln used

- Ceramic fiber paper or properly kiln-washed shelves, required to prevent glass from fusing to the kiln shelf. Fiber paper can also be used to create a channel in the glass during the firing process for threading purposes if you intend to hang your piece.

Let's look at this intriguing process for transfering images onto glass.

Step 1: Prepare a digital photo file in your imaging software. It works best to convert color photos to black and white, and resize as necessary at 300 pixels per inch for printing. It is cost effective to plan ahead and print as many pictures as feasible on your sheet of photo fusing transfer paper in order not to waste it.

Step 2: Warm up the laser printer by running five blank bond sheets through it before you place the photo fusing paper in it for copying.

Step 3: Remove the tissue coating from the photo fusing paper (below) and load it into the laser printer. Be aware of the orientation necessary to load paper correctly for your specific printer, and print on the coated shiny side of the paper.

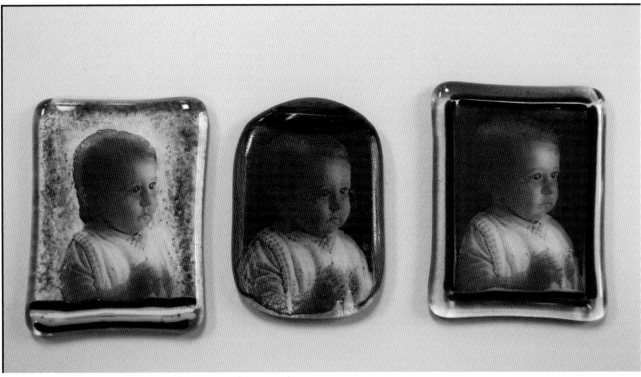

Three Images of Brenda. Artwork and photo by Brenda Cunningham.

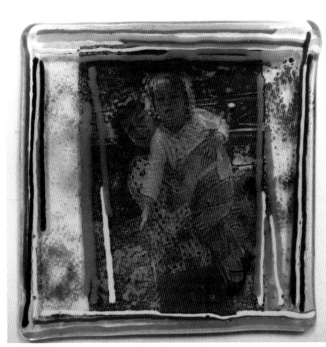

Mom and Me. Artwork and photo by Michelle Nicoletti.

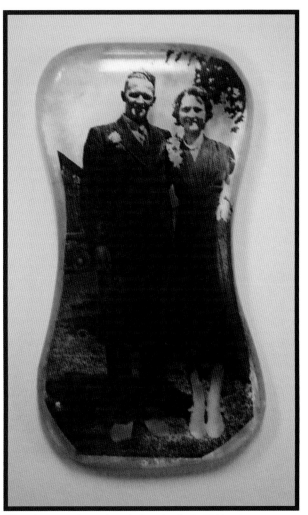

Grandparents. Artwork and photo by Emily Kirkland.

Step 4: Print your sheet(s), then cut the images out close to the edge of the photo. The images reproduce on a decal-type surface that will be separated later from the backing sheet of the fusing paper (steps 9 and 10).

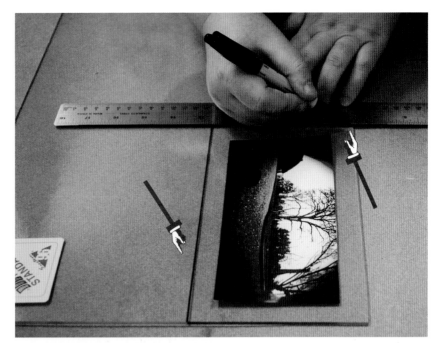

Step 5: Map out the quantity and specific sizes needed for your images on the sheet of glass using a sharpie marker and a ruler in order to know where to score the glass to break it (top right). Later these lines can be wiped clean with alcohol. You can decide whether you want the photo to go to the edge of the glass, or if you want to leave a border for aesthetic reasons or to create space for colored frit or stringers.

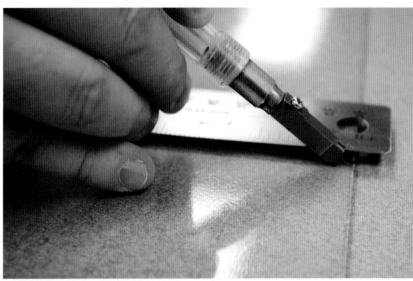

Step 6: Score the glass sheet using the glass cutter and ruler (middle). Then use the running pliers to apply pressure to the scored lines on the glass. This aids in the breaking process and makes for a smoother break after the glass has been scored. Note there is a mark on top of the running pliers that should align with the scored glass, which will also help you get a proper break (bottom).

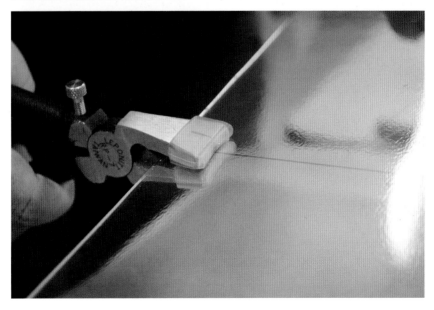

Step 7: Once a fissure has been produced by scoring, use your fingers to break the glass by snapping (right).

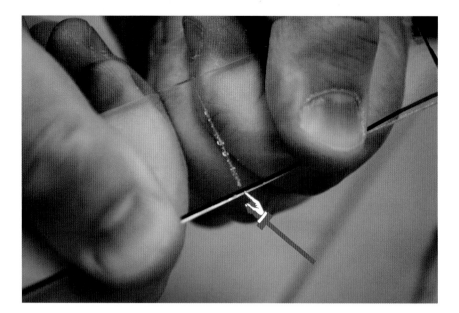

Step 8: Wash the cut glass; alcohol works best to eliminate fingerprints and sharpie marks.

Step 9: Fill a tray with distilled water and soak the printed image(s) face down for approximately 30 seconds. It is ready when you can gently slide the paper between your fingers and the decal easily lifts off the backing paper.

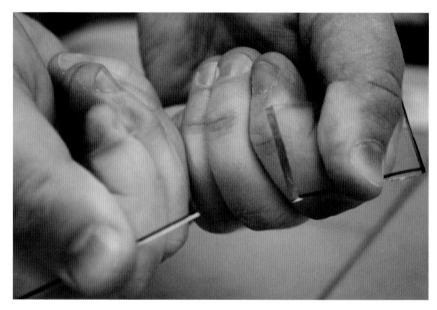

Step 10: Carefully slide the decal off the paper and onto the glass, printed side up. A helpful technique is to slide the decal partially off the top edge of the backing, perhaps a half inch, and position it on the glass where it should go, and then pull the paper out from underneath (similar to pulling a tablecloth out from under the dishes, right).

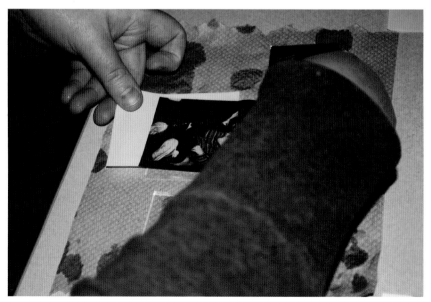

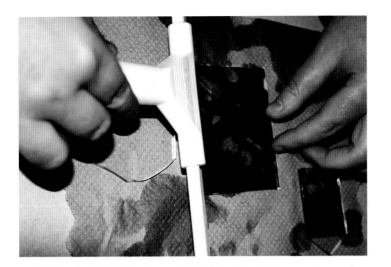

other with an additional piece of glass between them, which may have frit or stringers on it. Doing this will create depth. In using this last method, be aware that you can see through the glass to view both images simultaneously, so be sure to choose two images that will work well with each other.

Step 13: Allow to dry overnight (until completely dry) before firing. Prep kiln and load glass pieces inside.

Step 14: Fire between 1350 and 1375° F (735 – 745° C). The images will become sepia-toned once fired.

Step 11: Smooth the printed decal on the glass and eliminate any bubbles using your fingers or a squeegee. Gentle manipulation is necessary to avoid tearing and ruining your piece (above top). Blot with a paper towel.

Step 12: Apply colored frit or stringers as desired (above bottom). Or, if you wish, you can place an additional sheet of clear glass on top of the print decal, capping the image. This gives the best visual results. Still another option is to stack two seperate glass fusion pieces on top of each

A kiln schedule allows you to ramp up the heat at a prescribed Rate and then Hold that temperature for a specific amount of time. The schedule below illustrates our Paragon Janus Multi-purpose kiln with a Sentry 2.0 controller (with the switch turned to glass). Your schedule may vary depending on different kiln models. Consult your kiln's manual.

Step	Rate	Temp	Hold
1	400	1150° F (620° C)	.20
2	850	1375° F (745° C)	.45
3	9999	960° F (515° C)	.60
4	450	750° F (400° C)	.30
5	400	70° F (21° C)	0

Gallery

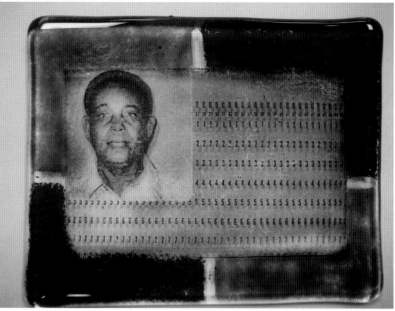

Grandpa by Patry Rodriguez. Photo © Brenda Cunningham.

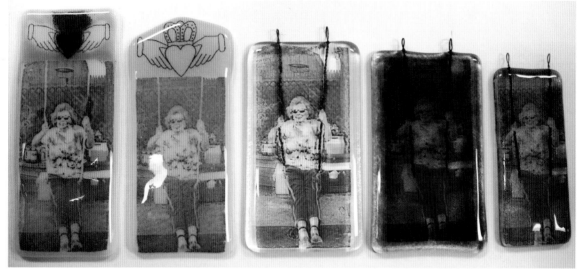

Grandma Series, Swinging. Variations in designs and glass colors (translucent, peach, etc.), some with 24 copper gauge wire (twisted) and embedded between glass or frit. Artwork and photo by Brenda Cunningham.

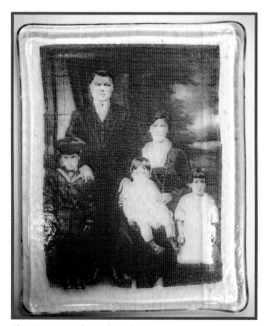

The Zinna Family Under Glass.

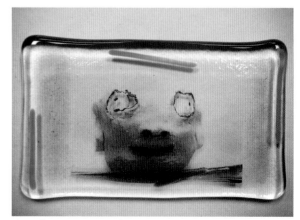

Photo fusing a picture of a sculpture.

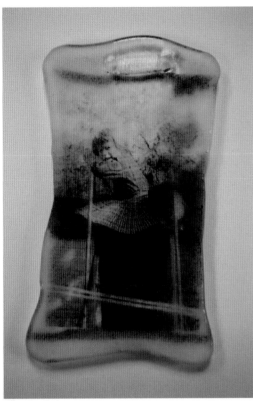

Elly, On Swing.

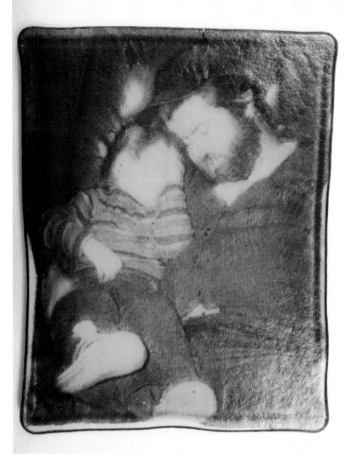

Dad and I, Sleeping. Artwork and photo by Brenda Cunningham.

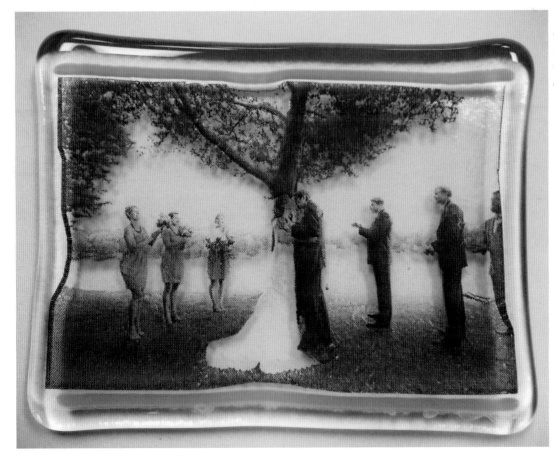

Wedding Photo baked on clear glass, colored stringers. Artwork by Chelsea Rohan; photo © Brenda Cunningham

5 alternative imaging processes

In this final chapter, we will explore several ways to make different kinds of visually arresting prints and mixed media pieces. For instance, you can print your own cyanotypes, which are the result of an imaging and printing process dating from the 1840s. You can convert your analog film into digital inverts for a fascinating transformation back to the 19th Century.

We will also explore the magic of using analog instant film emulsions to help produce one-of-a-kind artwork on such various substrates as watercolor and vellum papers, metal, and glass. And finally, we will consider byproduct art— the used portions leftover from the processes we've been discussing throughout this book. You will look at these "cast offs" in a new light and, in fact, may discover that the remnants created from these projects are as beautiful or as pleasing as the pieces they originally helped you create. As the maxim goes, "One person's trash is another person's treasure." In art, experimentation and using materials in new ways almost always leads to discovery.

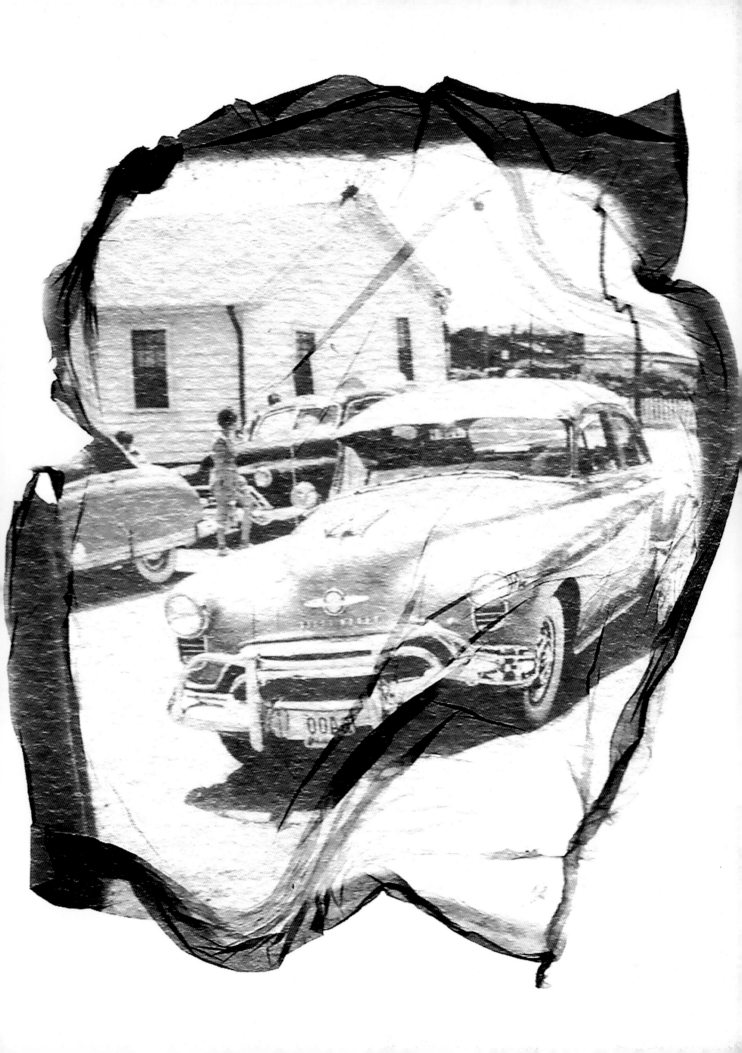

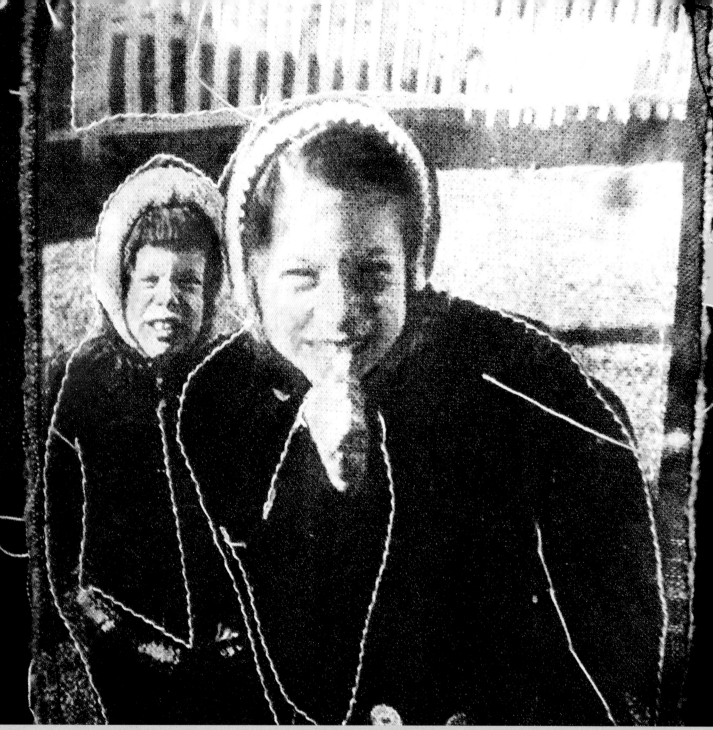

Sisters, Vest. Color-enhanced cyanotype with stitched details made a great wearable art piece when it was sewed onto a vest.

Working with Cyanotypes

Cyanotypes, sometimes referred to as blueprints, are the product of a printing process discovered by the English scientist, Sir John Herschel, over 150 years ago. An object or negative (or invert printed on transparency paper) is placed on a treated surface and exposed to either sunlight, to UV fluorescent light tubes in the 300 to 360–nanometer range (black light), or perhaps to Cooper-Hewitt vapor lamps. Fabric is one of the most common media to treat. The exposed substrate is then thoroughly rinsed with water to fix the image. This produces an insoluble iron salt, ferroferricyanide, that permanently stains the treated area. The key to making your own cyanotypes is to use the proper solution for treating your substrate.

Making Your Own Solution

You can purchase ready-made cyanotype solution or pretreated materials such as cotton and silk fabric, as well as watercolor paper or kits from sources like www.blueprint-sonfabric.com, or you can mix your own chemicals in proportions as listed below. Remember that cyanotype prints (blueprints) are permanent.

Water	Potassium Ferricyanide	Ferric Ammonium Citrate
1.2 gal.	4 oz	8 oz
2 qts	¼ lb	½ lb
4.5 gal	2 lbs	4 lbs
6.5 gal	3 lbs	6 lbs

One gallon will treat six yards of fabric and can be applied by dipping the fabric into a tub of the solution and/or brushing the mixture onto your surface. Make sure to keep your chemical solution in a light-tight plastic container, such as the brown jugs used for storing film developer (these are available online). Treated fabric, once dried, can be stored up to five years for use, but your images will be brighter depending on how soon you print. Any unused solution should be washed down the drain with copious amounts of water. Dilute with eight times more water than solution and never pour it down a storm drain or directly into the ground.

Lola Close-up.

Printing Cyanotypes

Cyanotypes will print on natural fiber surfaces such as cotton, silk, linen, or viscose/rayon, in addition to canvas, tote bags, watercolor paper, Bristol board, cardboard, canvas, or like porous materials, but not on synthetic fibers. You may be able to use cotton/polyester blends, but results may be less intense because only the cotton part of the fabric will print. As well, blended poly/cotton fabrics will fade since the cotton component tends to abrade. Make sure to pre-wash any fabric you use before exposing to the chemical solution.

First let's examine how to prepare a cyanotype with sunlight. After that, we'll look at how to build your own light box.

Step 1: Set up your cyanotype indoors away from sunlight and work as quickly as possible to avoid incidental exposure. I usually stretch a treated substrate, most often fabric, on top of a plywood base. You can also make a base from foam board or styrofoam board, or even corrugated cardboard, each of which can be cut to size if necessary with an X-acto knife. They are also easier if you need to pin your substrate to its foundation so it is perpendicular to the sun.

Changing the Color of Cyanotypes

When the cyanotype solution is applied to colored fabrics, secondary colors result: for instance, blueprint on raw white silk produces an off-white print with a blue-green field; or fuchsia fabric will create fuchsia with a purple field. But for the purpose of this chapter, we are going to talk about removing the blue to get brown and other colors.

Removing the Blue

There are a number of different household products and chemicals that will remove the blue color from the blueprint, leaving a pale yellow tint to the image. If you have used fabric for your cyanotype, you can rinse it in a solution that may contain any of the following:

Removing the blue from a cyanotype using phosphate-based detergent leaves the image with a yellowish appearance.

- Chlorine bleach: one capful for each quart of water

- Hydrogen peroxide: one capful for each quart of water

- Phosphate-based detergent: one capful for each quart of water

- Sodium metasilicate: one capful for each quart of water

- Sodium silicate: one capful for each quart of water

- Sodium sulfate: one capful for each quart of water

- Tri-sodium phosphate (TSP): one tablespoon to one quart of water is enough for six eight-inch squares of fabric

- Washing or baking soda: two capfuls for each quart of water

The fastest method to remove the blue is to use TSP. Available at building supply stores, this product is used to remove grease from walls before painting. Once the blue is removed it cannot be brought back, so work carefully and deliberately controlling the area by using brushes, cotton swabs, or washing the material and rinsing it when you get the desired effect. The end result is a print that has more of a yellow cast.

Adding Brown Toning

Applying a tannic acid to the yellow and white areas after the blue has been removed will create a brown tone. There are several methods in getting this result. Tannic acids are found in wine and dark teas, and I have even used coffee to get brown results.

One inexpensive method for smaller areas and projects is to use Orange Pekoe or Pekoe Cut Black Tea. For toning relatively small areas, steep 8 – 10 bags in 2 cups of boiling water. Let the fabric sit in bowls of the toning solution and periodically check the fabric, agitating the yellowed areas until the desired brown results. For toning larger areas, one pound of powdered tannic acid will tone ten yards of 54-inch fabric. Mix the tannic acid in proportion of one cup per two gallons of water (in plastic or glass containers).

Because tannic acid is a powder, it drifts into the air. Wear a mask and cover your work area with newspapers. But be aware that brown toning may fade in time. You can also hand color your prints with colored pencils, fabric crayons, fabric metallic colored permanent markers, and other fabric related pastels that are fixed by heating with an iron.

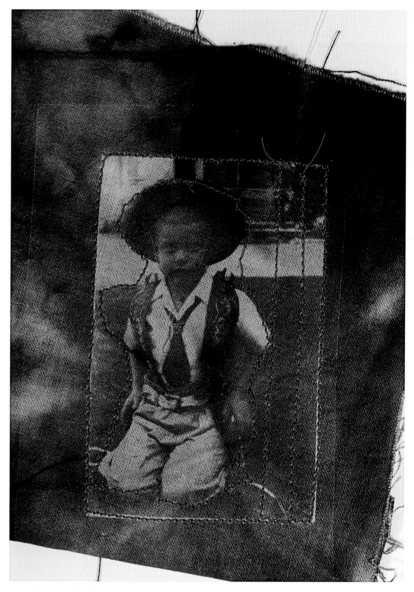

Cowboy. I stitched red thread onto this cyanotype since the brown tone left the print without much color and I wanted to call attention to this area of the print.
Photo © John Neel

Gallery

Creating cyanotypes is a fun way to incorporate your photographic images into wearable art projects, jewelry pieces, watercolor, altered books, or any number of project ideas. Changing the color is a snap when using colored pencils, fabric crayons, metallic colored permanent markers, and fabric related pastels.

Altered Book, Faithful Unto Death.

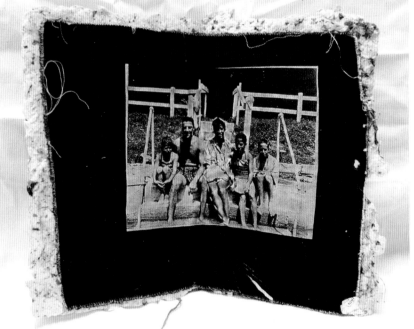

Interior of above book.

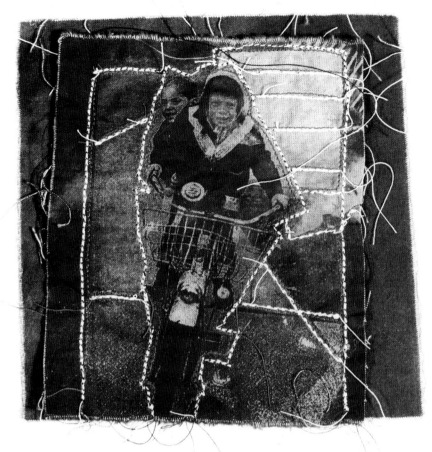

Bicycle for Two, Version 2. Cyanotype enhanced with tannic acid and threads.

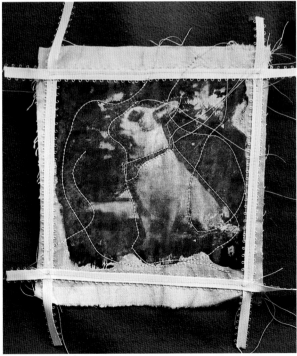

Brown-Toned Lola.

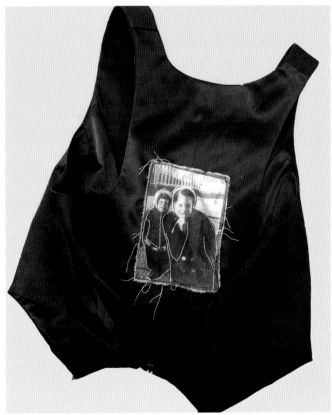

Sisters, Vest.

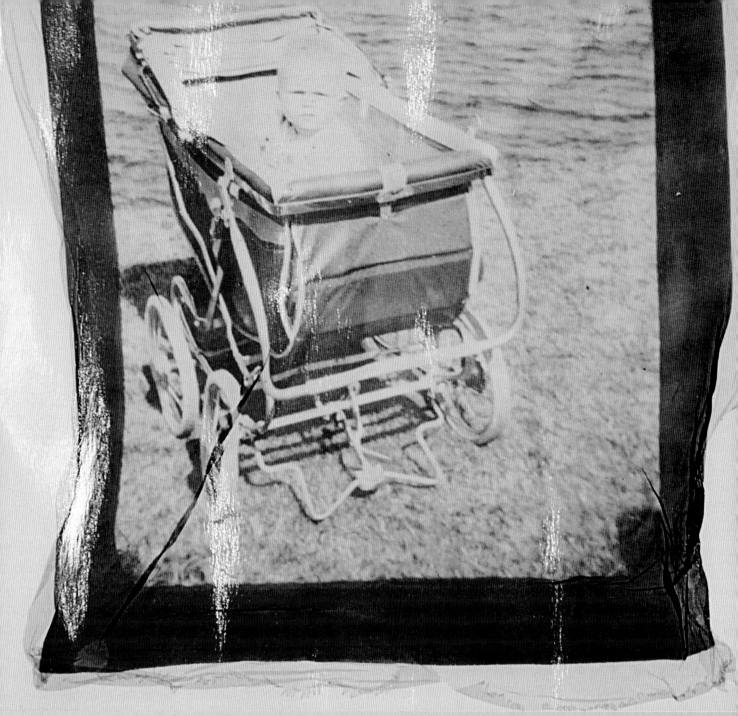

Len-it in the Baby Carriage. This image, from a positive film emulsion transferred onto cardboard stock, also incorporates the sepia cast-off byproduct from a negative transfer.

Instant Film Transfers: From Analog to Digital

The emulsion found in instant pull-apart film can produce very interesting artistic results when transferred to an assortment of substrates. The format for this type of film consists of a peel-apart packet that contains a negative paper with an emulsion side that faces a receiv-

ing print paper, along with chemicals that act to develop and fix the image. After an image is exposed, the film packet is pulled from its camera or printing machine and the emulsion develops for a specified period of time. The negative paper sheet is then peeled away to reveal a positive image on the print paper. You can transfer either the positive or the negative emulsion onto a substrate.

Although it may seem as if instant film has been completely supplanted by digital technology, that is not entirely true. The Impossible Project, a business consisting of former Polaroid employees who took control of Polaroid manufacturing equipment after that company stopped producing film, is slowing re-introducing the old Polaroid films that had become unavailable. However, at the time of this writing the company has not yet begun to remanufacture the peel-apart type of film.

However, Fujifilm is now producing FP-100C (color) and FP-100B (black and white) films, which are similar to the discontinued Polaroid varieties in terms of usability. You can use FP-100 in any camera that would accept 3.25 x 4.25-inch (85 x 108mm) instant film, including certain Holga brands. The FP-100 films are also functional in Daylab copy products, with old Vivitar printers, or Polaprinters. However, to keep things relatively simple, we are only going to look at transfer methods using the Daylab Copy System.

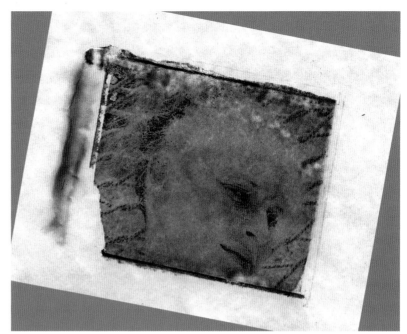

Kaitlyn, Beauty. A negative emulsion transfer onto vellum.

Materials for Emulsion-based Transfer

- Fuji FP-100C or FP-100B films
- Daylab instant copy system, or a camera that can house the appropriate instant film
- Small photo trays for soaking paper
- Brayer or squeegee
- Electric frying pan to maintain water temperature
- Protective gloves
- Optional items: Lysol (for negative transfers); gelatin packs; vinegar; various art papers; other paper substrates or metal, glass, wood, etc. to receive positive emulsion transfers
- Acetate or transparency sheet for positive emulsion transferring onto substrates such as metal, glass, wood, etc.

Caution: The chemicals used for developing instant film are somewhat caustic. Keep them away from your skin and eyes, read the health and safety instructions, and use protective gloves.

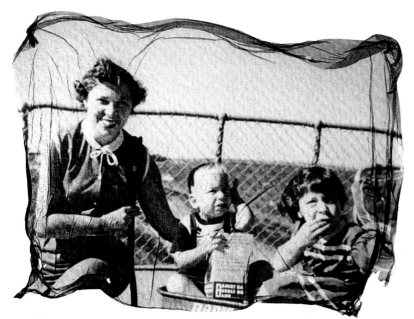

A positive emulsion transfer on watercolor paper

Positive Emulsion Transfer

The method for positive emulsion transfer uses fully developed instant film to transfer images onto various substrates.

Step 1: Load the instant film packet into the Daylab film holder to the right of the machine's 4 x 6-inch (101 x 152mm) glass object window. Then place a photo print or inkjet print, or even a relatively flat 3-D object, on top of the glass window.

Step 2: Turn on the machine by pressing the rocker switch and wait for the green light to display. Set the exposure knob to the middle as a starting point. Push the print button to expose your print to the instant film.

Step 3: Start the development process by firmly grabbing the film's tab and pulling the film through the processing rollers, removing it from the Daylab. It is important to pull in a continuous, swift movement—don't stop halfway. A smooth movement distributes the developer evenly. Make sure the room is dark if using Fuji FP-100 film because light will drastically affect the outcome of the develop-

ment. Wait for the film to develop according to its instructions (two minutes for Fuji FP-100C).

Step 4: After the allotted development time, hold the black film tab and steadily but rapidly peel the negative and positive sections of the film packet apart (above). Set the black negative portion aside.

Step 5: Analyze the print. If it is too dark, turn the exposure knob in the + direction and expose again on another film packet. If the print is too light, turn the knob in the – direction.

Step 6: Let the positive print dry completely for about half an hour. Then, in preparation for separating the positive emulsion from its print backing, cut off the white edges around the image area.

Step 7: Soak and agitate the positive print for four minutes in an electric frying pan filled with water that has been preheated to 180 – 200° F (82 – 93° C).

Step 8: Separate the positive emulsion from its gelatinous backing. It is ready when you can gently lift the film of emulsion from the its backing paper (below) — sometimes tiny bubbles appear under the emulsion).

Photo © John Neel

To do this, take the emulsion, still on its backing, out of the frying pan while wearing protective gloves and place it in a photo tray filled with cool water. Gently push the emulsion off the backing paper using your forefinger or thumb to lift it up. Leave this separated emulsion, looks and feels a lot like cellophane, floating in the cool bath while discarding the backing paper.

Step 9: Remove the image emulsion from the water by placing a transparency sheet under the emulsion and lifting it out. The emulsion will adhere to that clear sheet. It is ready to be placed, emulsion side down, onto your

substrate (watercolor paper, glass, whatever you choose). However, be aware that the image will appear in reverse unless you decide to flip the emulsion over.

Step 10: Transfer the emulsion onto your substrate with the transparency "lift" sheet. Often the Fujifilm FP-100 emulsion needs to be adhered with some sort of glue. So brush the substrate with Mod Podge before laying the emulsion on it. Then smear some Vaseline on the substrate to enable the emulsion to slide around easily. Sometimes the Fuji emulsion will roll up, so it is best to apply additional Mod Podge before it dries.

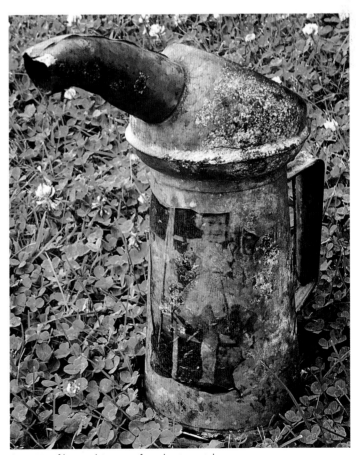

A positive film emulsion transferred onto metal.

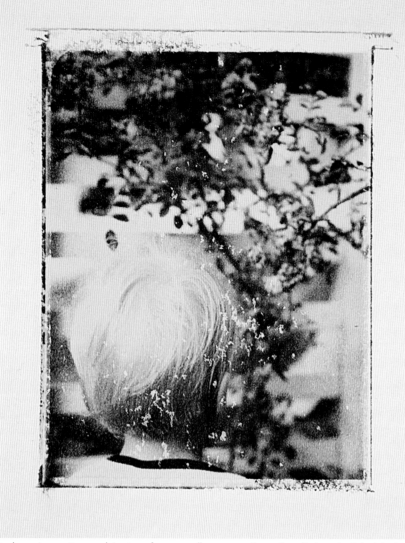

Andrew. A negative emulsion transfer onto vellum paper. Artwork and photo by John Neel.

Negative Emulsion Transfer

This process uses the image emulsion from the negative portion of the instant film packet instead of the positive print emulsion.

Step 1: Expose a print or postcard or some other type of flat image on the Daylab object glass in the same way as making a positive emulsion transfer (see pages 138-139). Make sure you are in a dark room when using Fuji film because the negative emulsion side of Fuji FP-100C will continue to develop rapidly and go completely black when exposed to light after being separated from the positive emulsion paper. That is not good because you want to retain undeveloped emulsion from the negative for this process.

Step 2: Pull the film smoothly through the processing rollers of the Daylab as you did when making a positive emulsion. However, at this point develop the film for a shorter time period; approximately 40 seconds instead of two minutes when using Fuji FP 100C. The shorter time leads to incomplete development, leaving a significant amount of pigment remaining on the negative. In a dark room, pull to separate the negative and positive sections of the film. This will result in a much less saturated, almost sepia-toned print, which you will set aside.

Step 3: Prepare the substrate. I usually use a paper substrate when transferring the negative emulsion, and there are two ways to go about this. You can choose the technique that works best for you.

Wet transfer method: Most artists find this much easier than the dry method. Soak the paper substrate in warm water (80 – 100° F; 27 – 38° C) until it is soft—less than a minute. I often use Arches hot-press 140# watercolor paper. Remove it from the water and drain off standing water. Place it on a flat surface and lightly squeegee any remaining excess water.

Dry transfer method: Spray your substrate lightly with Lysol. For this method, I like to use vellum paper. I find that the Lysol aids the transference of emulsion when the negative comes in contact with the paper substrate. Squeegee the substrate and let it dry for at least 30 seconds.

Step 4: Put the negative sheet face down on the prepared paper (right) and roll with the brayer. Be careful not to let the negative move in relation to the paper. Use firm pressure with the brayer in the same direction for at least one minute and 30 seconds.

Step 5: Separate the negative's backing paper from the prepared substrate. It is important to keep the room dark while the burnished negative sits on top of the substrate. Then you can turn the light on. Peel the negative back slowly. If the image starts to lift off the substrate, try starting from another corner. Again, don't worry too much if you lift some of the color off your substrate—that sometimes adds a unique quality to the final image. Experiment with the amount of time you leave the negative on the substrate to note the variations in outcome.

Step 6: If desired, neutralize the film chemistry in a post-process-ing soak. While this step is not absolutely necessary, it makes the final colors more vibrant. I recommend a post-processing soak in a weak acid, such as vinegar. This strengthens the transfer's colors. Use a solution of one part vinegar to four parts water and soak for no more than 60 seconds with agita-tion. Then wash it in running water for four minutes and air-dry.

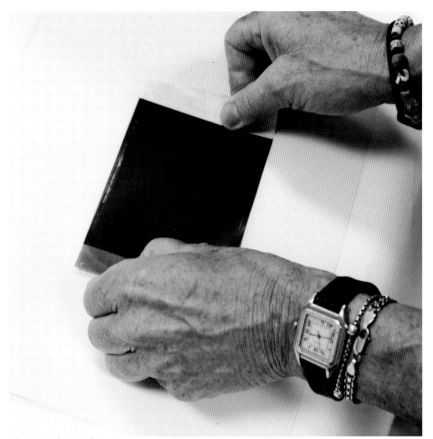

Photo © John Neel

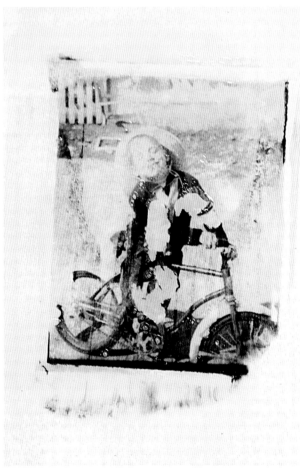

My brother, Len-It. The yellow cast at the edges of this negative emulsion transfer is the result of dried chemi-cals, which I feel give an interesting look to the final image. This chemical residue can be wiped away if you find it undesirable.

Film Transfers:
Next Steps and Beyond

In the negative emulsion portrait of my sister-in-law Valerie (below left), I applied Lysol spray on a vellum paper substrate. After rolling the negative on the substrate with a brayer for 40 seconds, I placed the negative and substrate into hot water (180° F; 82 C) with a packet of clear gelatin for a minute before removing and peeling the negative backing from the vellum. The gelatin in the hot water transferred to the substrate, leaving a glossy sheen on the image.

As you can see from this series, I had a lot of fun scanning the negative emulsion image back into my computer. I was then able to take additional steps to recreate more unique pieces of photo art by scanning the image seen to the right. With the tools in your image-processing program and some creative experimentation, you can rework these images to print virtually an endless number of variations on a theme.

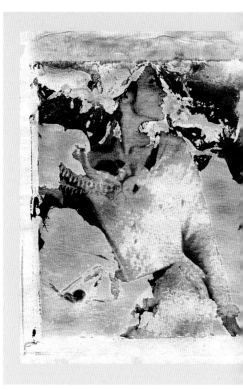

Valerie, in Marriage of Figaro, Version 2. This version a negative emulsion transferred onto Lysol coated reg bond paper. I then scanned the finished work.

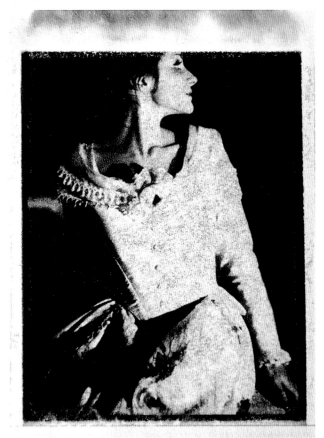

Valerie, in Marriage of Figaro.

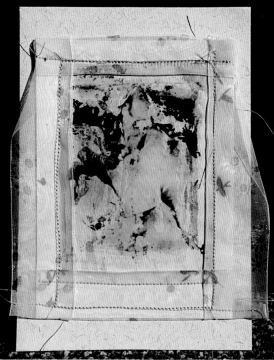

Valerie, in Marriage of Figaro, Version 3. After printing the scanned image from Version 2, I then applied the Seksten method (pages 86-91) but lifted the transparency much sooner than usual, retaining most of the image on the transparency. I enhanced the image on the transparency by sewing it onto decorative paper and surrounding it with ribbon.

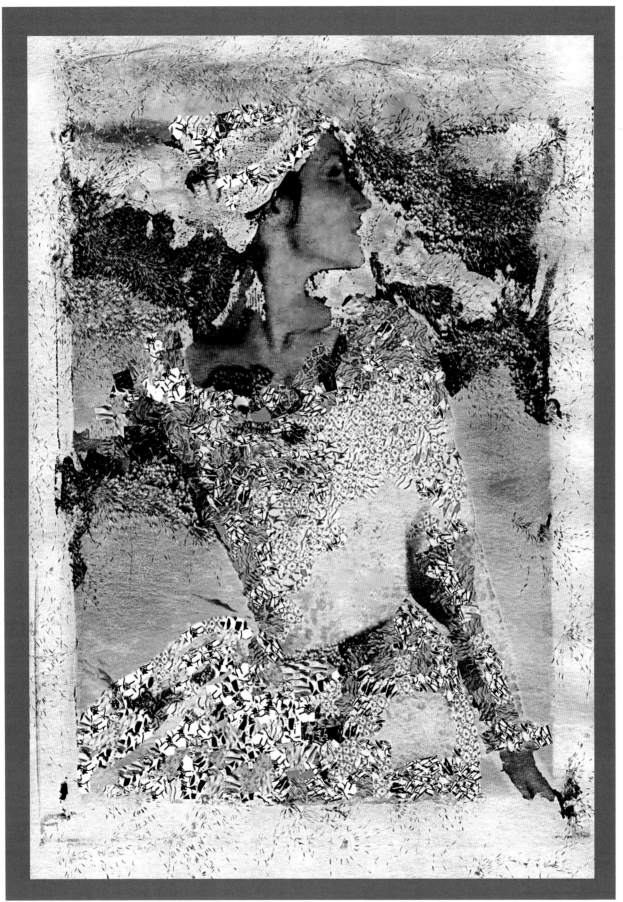

Valerie, in Marriage of Figaro, Version 4. You can do any number of enhancements to the scanned photo in several different imaging programs to produce a series of completely altered versions of the negative emulsion transfer. This final version was manipulated in Studio Artist.

Gallery

It is gratifying to output analog images onto a variety of substrates (metal, fabric, glass, watercolor and vellum paper), and then enhance further using digital software techniques. I find this swing between the analog and digital pendulum to be the most satisfying palette for artistic photography.

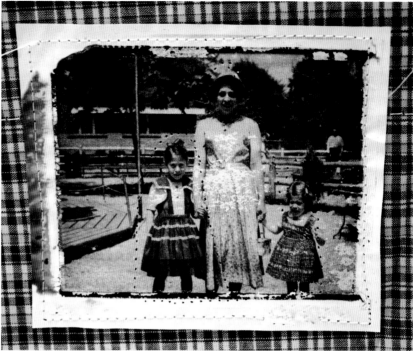

The Girls. A negative emulsion transfer on cardstock that has been sewn onto fabric.

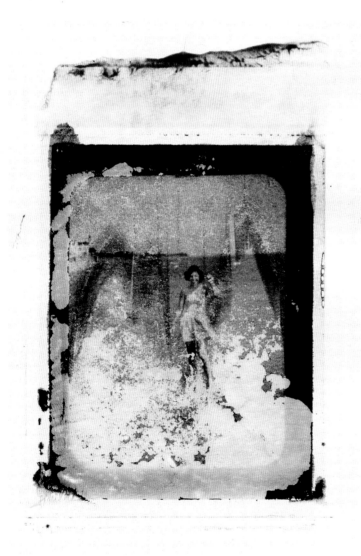

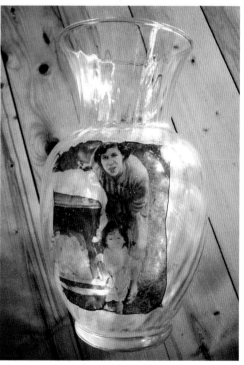

Nancy and the Baby Carriage, Version 1. A positive film emulsion transfer onto a glass vase.

Maida by the Seashore. A film negative emulsion transfer onto vellum paper.

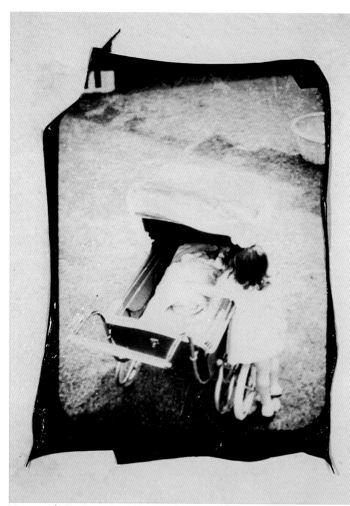

Nancy with Carriage. A positive emulsion transfer onto vellum paper using Fujifilm FP-100C. The upturned corners could be more securely adhered with a little Mod Podge.

Family. Positive emulsion transfer adhered to fishnet stocking over cardboard stock.

Untitled. A negative emulsion transfer onto vellum paper. Artwork and photo by John Neel.

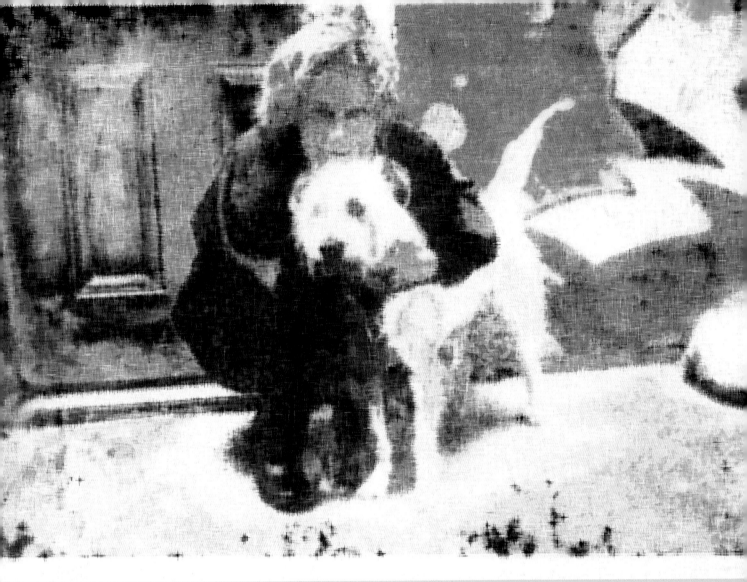

My Editor and Her Woof. You can make wonderful images from used sheets of Sheer Heaven and from other media byproducts. Photo © Kara Arndt; additional artwork by e.g. horovitz.

Byproduct Art

More often than not, artistic souls find the beauty in nearly everything that surrounds them, even in the discarded products from various transfer techniques! In fact, such byproducts can often be as alluring as the original output. So beyond the obvious measure of scanning leftover image material back into the computer and manipulating the resulting image files via software, I have created some new methods to embellish these cast-off items and produce spinoff art pieces. I sometimes even prefer the results I have gotten from byproducts to the original outcomes. Consequently, this chapter describes some of the methods I have used to utilize byproduct materials.

I utilized Christie's technique with a slight addition by first spraying the paper with olive oil and then brushing it a second time in order to get a more even consistency on the paper. I really think some of the pieces created using this technique are quite stunning, including the lovely muted family portrait below and the image to the left, which exhibits a truly translucent quality.

The Linn Method

One of my former students, Christie Linn, has experimented with ways to use discarded toner images that are left on sheets of bond paper after they have been used with a solvent such as Xylol or Citra Solv during the transfer process. In doing so, she and I discovered that the beauty in such cast offs often results in higher art than the images transferred to the original substrates. Instead of tossing out the used prints on the bond transfer media, Christie coated them with olive oil (yes, olive oil) and sandwiched each between two pieces of paper toweling. She then let the new artwork dry in that manner for 24 hours (natural drying over time seems to give the best results). You can follow this method and end up producing a paper print with tooth that rivals the look of manufactured vellum and, in fact has similar strength and viscosity.

This becomes an environmentally savvy way to make your own vellum-quality printed stationery. And if you brush on a coat of used oil from cooking, as I have done on occasion, the paper takes on a permanently dyed quality. Naturally, you can also enhance color by applying a variety of paint media or food dyes.

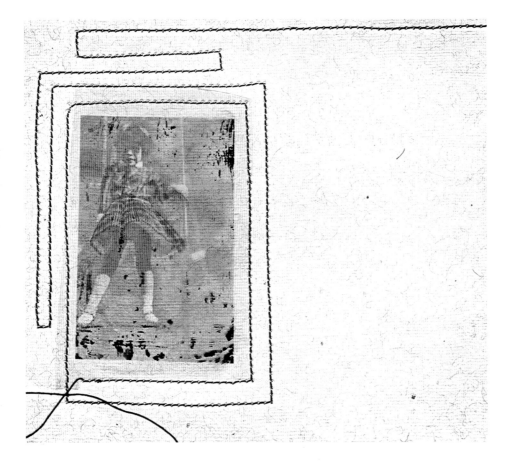

Using Cast Offs from Inkjet Transparencies

You can make really interesting art pieces from the ghost-like images left on inkjet transparencies after transfer using the Seksten method (pages 86-91). Make sure the byproduct transparency is completely dry and apply Mod Podge to it. Place that sheet with the coated side down on another substrate like watercolor paper or cardboard. If you choose, you can embellish further using thread, ribbon, or colored pencils. You can sew a transparency byproduct onto a new substrate (above), or even sew the transparency in a slightly offset position on top of its original Seksten print, and of course you can add creative embellishments that you feel will enhance the art piece (right).

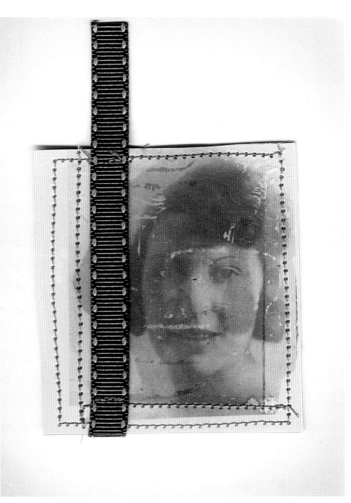

Alcohol with Inkjet Transparencies

Because I knew that a 70% solution of Isopropyl alcohol is effective to aid transfers with Sheer Heaven paper (see pages 74-79), I wondered what would happen if I used that solution when transferring an image from an inkjet transparency to vellum art paper. The resulting vellum print was somewhat faded and subdued, and I was not entirely satisfied. But I was struck by the quality of the residue left on the transparency after the transfer attempt. So I decided to place the used inkjet transparency slightly offset on top of the subdued image, adhering it with Mod Podge. This produced a much more dramatic piece of art (above) and gave me the idea to scan the image for additional processing using imaging software.

Liquid Sculpey Spin-off

Occasionally the image left on the spin-off from Liquid Sculpey, which is the bond paper that is peeled from the clay after baking, is quite lovely and can be combined with other media to make a beautiful art piece. In the image to the right, there is still a certain amount of residual color from the original embellishment that had been done with colored pencils. Additionally, bits of gold leaf that did not make it onto the clay still cling to the spin-off. The remaining oil embedded in that bond sheet gives the image additional tooth. I paired this byproduct with decorative paper to produce a new version of a young cowboy (see original Liquid Scupley cowboy on page 45)

So, it is a great idea to recycle your images by holding onto your byproducts. With some creative thought and an attitude of experimentation, you can produce new pieces of art, often ones that outshine the original. Formed art is the order of the day, the truest expression of humanity, the spirit that evokes primitive urges as well as the celebration of artistic beauty. Invent, look, rediscover, and create. Use your family's historical analog images, newer digital photo files, video images, and even your phone photos. Apply your imagination to some of the techniques outlined here to recolor your life and reflect on what stimulated you in the first place towards pictorial representation. Above all, art.

Gallery

Various cast-offs from different transfer methods such as Seksten, Citra Solv, Linn, and others can be used to create one-of-a-kind pieces. Besides being environmentally friendly, these byproducts in some instances may be more dazzling than the original results. Always save the residue pieces of your work because they may become everlasting keepsakes.

Byproduct from Seksten method on inside of sewn card.

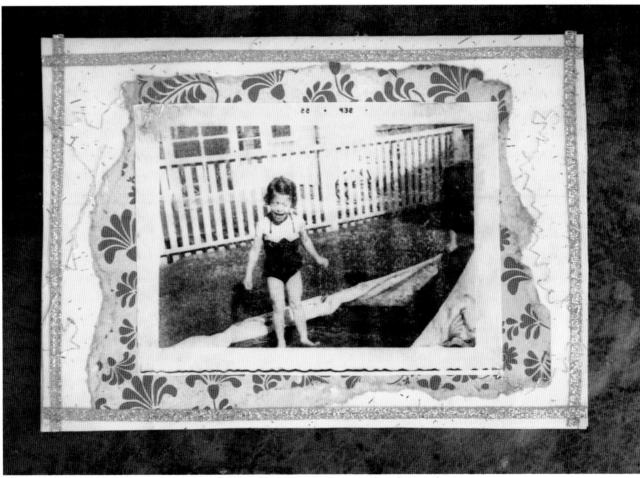

An image on bond paper left over from a Citra Solv transfer that has been mounted on decorated art paper.

A bookmark made using the Linn method.

Twin Mama. An altered portrait from a photocopy sheet using the Linn method sewn onto decorative paper.

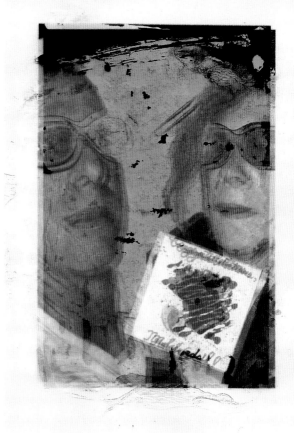

Newlyweds in Stereo. A used transparency from Seksten method adhered onto the original Seksten transfer to create a 3D quality to the image.

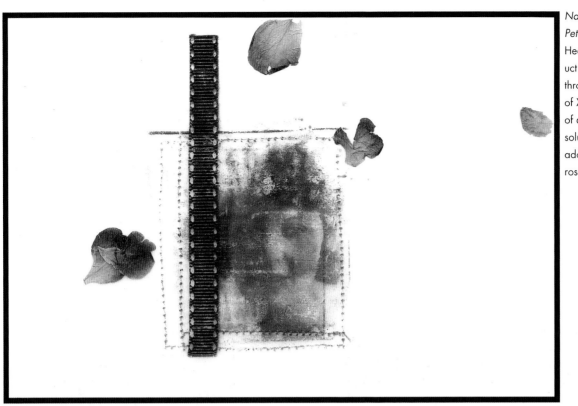

Nana, with Rose Petals. A Sheer Heaven byproduct is derived through the use of Xylol instead of an alcohol solution, further adorned with rose petals

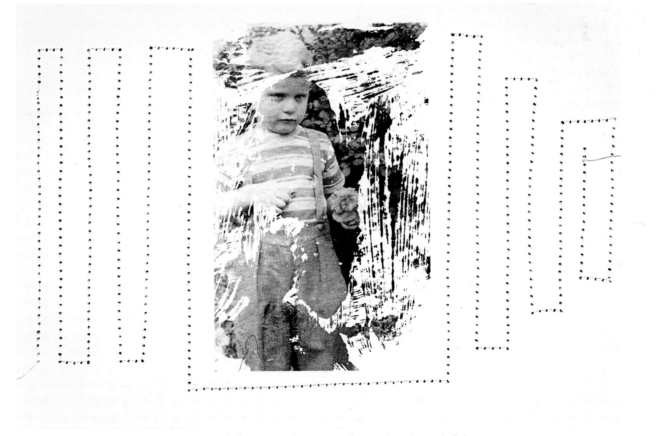

A transfer from a used inkjet transparency applied to watercolor paper with sewn thread to embellish.

Transfer Summary for Papers and Solvents

Method	Printer	Reverse image?	Paper	Transfer medium
Tape Transfer	Laser	No	Bond	Tape
Citra Solv	Laser	Yes	Bond	Citra Solv
Gloss gel	Inkjet or Laser. Laser gives better finish	No if gel directly on image; Yes if gel on paper/ canvas	Bond	Gel
Seksten	Inkjet only	Yes	Inkjet transparency	Mod Podge
Healey	Inkjet	Yes	Bond	Mod Podge
Sheer Heaven	Inkjet	Yes	Sheer Heaven paper	70% alcohol spray
Soap-ink turpen-tine	Inkjet	Yes	Bond	Soap-ink turpentine mixture
Lazertran	Laser	Yes	Lazertran Water-slide Decal	Lazertran decal in Wa
Grafix	Inkjet	No	Grafix inkjet shrink film (transparent or white)	Bake Grafix film 2 – 3 minutes
Premo Sculpey Polymer Clay	Laser – black and white image. Use pencils to add color	Yes	Bond	Spray back of bond with 70% alcohol spr and burnish
Liquid Sculpey	Laser – black and white image. Use pencils to add color	Yes	Bond	Let image leach on polyclay for 5 minute
Photo fusing	Laser – black and white only	No	Photo fusing paper	Photo fusing decal in distilled water

urnish	Process	Transfers to
Spoon	Burnish; put in water; rub paper off	Anything
Spoon	Lay face down; brush Citra Solv on back; burnish; wait a few seconds; remove – iron if onto fabric	Paper, fabric, tissue, wood, etc. (Porous surfaces)
No	Gel directly on substrate and lay bond face down. Let dry overnight and rub bond off with water	Canvas, paper etc.
rayer/spoon	Brush Mod Podge where image will go; burnish; wait a few minutes	Paper, fabric, wood, etc.
Brayer	Brush Mod Podge where image will go; burnish; wait a few minutes	Paper, fabric, etc.
Brayer	Spray image with 70% alcohol till shiny; lay face down; burnish	Paper, wood, etc.
Spoon	Brush mix directly on image; wait 10 seconds; flip over; burnish onto substrate	Paper, fabric etc.
Squeegee	Depending on substrate— follow instructions in book	Metal, canvas, glass, candle wax, etc.
No	Film is baked and shrinks to 60% original; cut to size	Can be glued to things when done or used in jewelry, tag art, etc.
oller/brayer	Lay image face down on polymer clay; burnish and let sit for 10 minutes; 70% alcohol on back; burnish and bake for 2 minutes; remove bond paper; bake 15 – 20 minutes	Polymer clay: jewelry, magnets, framed pieces, etc.
No	Lay image face down on Liquid Sculpey for 5 minutes; then bake for 15 minutes; remove bond after baking	Liquid clay: jewelry, magnets, framed pieces, etc.
Squeegee	Warm printer before loading paper and printing image; cut prints to size and prepare glass; slide decal on glass and apply frit/stringers; dry overnight; fire in kiln	Glass

INDEX